Gwen John

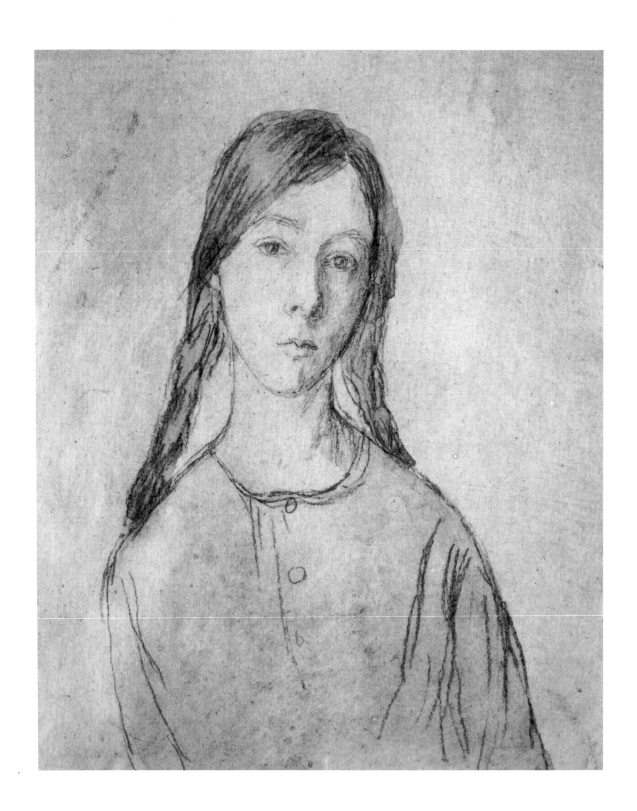

Gwen John

Mary Taubman

London · Scolar Press

First published 1985 by
SCOLAR PRESS
James Price Publishing Limited
13 Brunswick Centre
London WC1N 1AF

British Library Cataloguing in Publication Data

Taubman, Mary
 Gwen John.
 1. John, Gwen
 I. Title II. John, Gwen
 759.2 ND497.J6/
 ISBN 0–85967–690–0

Origination by Waterden Reproductions Limited
Typeset by Gloucester Typesetting Services
and printed in Great Britain by
The Roundwood Press Kineton Warwick

Frontispiece: Self-portrait
1905–10, pencil and wash. $10 \times 8\frac{1}{4}$ in (25.5×21 cm.)
Private collection

Preface

Within only a few years of her death, the details of Gwen John's life had become mysteriously obscured and inaccessible. Her solitary way of life meant that little about her was on record and her known dislike of publicity caused friends to be reticent on her behalf. Perhaps it was the intervening war years which made her seem even more remote by the time I was becoming interested in her in the early 1950s. At that time, the only existing study of any length devoted to her was the sympathetic chapter in Sir John Rothenstein's *Modern English Painters*, which had appeared in 1952. This drew upon the testimony of Augustus and Dorelia John. Their memories of Gwen John, though not always very accurate in the matter of dates and names, were of the greatest value and interest. It was through Henry Lamb, to whose great kindness I remain always indebted, that I was able to meet and talk with the John family. Gwen John's nephew and heir Edwin John gave me access to her papers and notebooks. To him I owe the greatest debt. His generosity and his sympathetic interest in the work made it possible for me to reconstruct Gwen John's life insofar as I have been able to do so.

I would like to thank Edwin John's son and daughter Ben and Sara John for allowing me to reproduce Gwen John's pictures and to quote from her letters. Without their kind cooperation this book could not have been made.

I am grateful to other members of the John family: Vivien White and Romilly John provided me with valuable information and Muriel Matthews and Betty Cobb were generous with detailed replies to my letters.

To Michael Holroyd I owe particular thanks for his unfailing help with information and material connected with the John family.

There are many other people who have helped to bring this book into being. I would especially like to thank the following: Janet Arnold, Lilian

Browse, Beverly Carter, Bill Cleever and the Contemporary Art Society of Wales, Bethia Colam, Elisabeth Davison, William Derby, The Anthony d'Offay Gallery, Anne Goodchild, Richard Green, Francis Greenacre, Thomas Grischowsky, Ben Johnson, Graham Langton, Bridget Latimer, Brigid McEwen, Margaret McKenzie, Sœur Madeleine St Jean de la Présentation de Tours, Stefanie Maison, Michael Salaman, Sandra Martin, Alison Mykura, Michael Palmer, Paul Rees, Anna Southall.

I am also grateful to all the owners of pictures reproduced in the book and thank them for their cooperation. I hope that perhaps through the appearance of the book we may hear from the three owners with whom we have been unable to make contact.

My husband Robert Taubman has contributed to the book by supplying indispensable practical support; to my daughters Alison and Jane I am grateful for their constant interest and many useful suggestions. Many of my thoughts about Gwen John have evolved in conversation with Derek Clarke. To him, and to Jane Miller, whose friendship has kept me on course, I express my warmest thanks.

Contents

Events in the life of Gwen John

1876 22 June, Gwen John born at Haverfordwest, Pembrokeshire, Wales, the second of four children. Her elder brother Thornton had been born 10 May 1875.

1878 4 January, brother Augustus born.

1879 3 November, sister Winifred born.

1884 11 August, mother Augusta dies.

Autumn, family moves to Tenby where Gwen is educated by a series of governesses, and from 1890 at 'Miss Wilson's Academy'.

1893–4 Attends Miss Philpott's Educational Establishment, 10 Princes Square, London.

1895 Attends Slade School of Fine Art, London (until 1898). Lifelong friendship with Ursula Tyrwhitt begins.

1898 Autumn, to Paris with Ida Nettleship and Gwen Salmond. Studies at Académie Carmen under Whistler.

1899–1903 Based in London.

1900 Spring, first picture shown at the New English Art Club (exhibits there irregularly until 1911 (a total of 12 paintings).

1902 January–April, stays with Augustus and Ida John and their baby in Liverpool. Paints *Self-portrait* for Slade show.

1903 March, exhibition at the Carfax Gallery, London: *Paintings, pastels, drawings and etchings by Augustus E John. Paintings by Gwendolen M John* (3 paintings). Summer, Winifred leaves for United States. August, sets off to walk to Rome with Dorelia McNeill.

1903–04 Spends winter at Toulouse with Dorelia McNeill.

1904 Spring, arrives in Paris with Dorelia McNeill; they take lodgings at 19 boulevard Edgar Quinet and acquire a cat (Edgar Quinet). Embarks on career as artists' model. Summer, meets Auguste Rodin and by August has begun to

pose for him. They become lovers. November, installed, at Rodin's instigation, at 7 rue Ste Placide.

1905	Summer, Rodin begins work on *Monument to Whistler* for which Gwen John is the model.
1907	Winifred visits her in Paris. March, moves to 87 rue du Cherche Midi. 14 March, death of Ida John in Paris.
1908	Summer, the cat Edgar Quinet is lost.
1909	February, begins to experiment with gouache. Autumn, moves to 6 rue de l'Ouest. The New York lawyer John Quinn makes first attempt to buy one of her pictures (from New English Art Club winter exhibition).
1910	June, John Quinn attempts to buy two of her pictures from New English Art Club. July, correspondence with John Quinn begins. From now until his death in 1924 he buys everything she will sell him – a total of about twenty paintings and about eighty drawings.
1911	January, moves to 29 rue Terre Neuve at Meudon just outside Paris (while retaining the room at 6 rue de l'Ouest as a studio). May, two pictures acquired by the Contemporary Art Society for the Tate Gallery (presented to the Tate in 1917).
1913	?January. Is received into the Catholic Church.
	John Quinn receives his first picture from her (*Girl reading at the window*); February, it is exhibited in the Armory Show. About this time begins portrait of Mère Marie Poussepin (versions of it a main preoccupation until about 1917).
1914	August, outbreak of war. Decides to stay in France. Sometime during the war gives up career as model.
1917	17 November, death of Rodin.
1918	Early autumn to Brittany (Pléneuf); returns to Meudon October. Gives up room at 6 rue de l'Ouest. November 11, war ends.
1918–19	Winter, returns to Pléneuf. Spends next nine months at château de Vauxclair, Pléneuf, drawing local children and children of visiting friends.
1919	September, returns to Paris. Begins *The convalescent* series. October, death of Isabel Bowser. Exhibits for first time at Salon d'Automne – nine drawings, one painting (*Mère Poussepin*).
1920	Exhibits at the Société des Artistes Français (the Grand Salon), the Société Nationale des Beaux Arts (the New Salon), and the Salon d'Automne – a total of thirteen drawings and one painting. August–September, John Quinn begins regular payments of $750 per annum. September, meets Jeanne Foster.
1921	Exhibits at the Salon d'Automne seven drawings and two paintings. July, visits England and stays with Arthur and Rhoda Symons. August, meets John Quinn for first time when he visits Paris.

1923	Exhibits at Salon d'Automne three paintings (all are bought by Quinn).
1924	28 July, death of John Quinn. Exhibits at the Société Nationale des Beaux Arts and the Salon des Tuileries a total of seven paintings.
1925	Exhibits at the Société Nationale des Beaux Arts one painting. Portrait of Chloë Boughton-Leigh is purchased for the Tate Gallery.
1926	May–July, exhibition of her work held at the New Chenil Galleries, London (simultaneous exhibition of work by Augustus is shown in a separate room). *Dorelia in a black dress* is purchased by Duveen Paintings Fund for Tate Gallery. Purchases piece of land at 8 rue Babie, Meudon and plans to build studio there. At instigation of Augustus purchases Yew Tree Cottage near Fordingbridge, Hampshire, close to Augustus's home, Fryern Court. Spends some weeks there in late summer.
1928	Visited by John Quinn's sister Julia Anderson and her daughter Mary (later Conroy), who buy a picture. Begins to make gifts of drawings, once each week, to Véra Oumançoff. September, second short stay at her cottage in England.
1929	March, Bridget Bishop sits for portrait. Summer, further visit from the Andersons. Visit from Maynard Walker of the Ferargil Galleries, New York (at request of Mrs Anderson), and exhibition is arranged for following winter in New York. She fails to send pictures. Gifts to Véra Oumançoff continue.
1930	From about this time output of paintings and drawings diminishes, probably because of ill-health and failing eyesight. Further visit from Maynard Walker and exhibition once again arranged; again pictures are not sent. Resists later attempt by Mrs Cornelius Sullivan, also of New York, to obtain work for an exhibition at her gallery.
1936	About this time begins to live in the chalet-studio at 8 rue Babie, Meudon, while retaining 29 rue Terre Neuve flat. Becomes increasingly interested in contemporary art and in the theory of painting and attends André Lhote's lectures.
1937	Maynard Walker again visits her and finds her now apparently reluctant to sell any of her accumulated pictures.
1938	7 April, death of her father.
1939	3 September, outbreak of war. Travels to Dieppe. 18 September, dies at the *hôpital civil*, avenue Pasteur, Dieppe.

Introduction

One evening in 1905 or 1906 Gwen John wrote to Rodin from her lodging at 7 rue Ste Placide in Paris: 'My room is so lovely. If you knew how charming I find it you would think that I exaggerate its beauty perhaps. But I am going to do some drawings or paintings to show you what I find so lovely in it. I am going to do some in the mirror of my wardrobe – with myself as a figure doing something. They will be like Dutch pictures in subject-matter.' This vivid and intimate glimpse of a life is at the same time an illustration of what, in Gwen John's work, is one of its most striking characteristics – namely the ability to view her subject-matter with simultaneous detachment and intense personal involvement. And it is indeed quite simply as a 'figure doing something', observed with tender detachment, that she herself appears in the picture she went on to paint in her rue Ste Placide room: *La Chambre sur la cour* (Pl. 21).

The closely-woven interaction of self and subject is a unifying theme running through her entire œuvre from youth to maturity. An extraordinary feeling of self-absorption emanates from her work. Gwen John's subject-matter is taken largely from her own immediate surroundings, and a selection of her work such as this one, spanning her life from youth to maturity, reinforces this sense of self. For the most part, and especially in her earlier years, her subjects were her friends, her rooms, her cats, her own person and the people and places she observed in going to and from her solitary lodgings. In the comparative affluence of later life, when she was living in the Paris suburb of Meudon, she employed a very few paid models – most of them local women and girls, not the professional artists' models of Paris. Obsessively, she painted each of these women over and over again. The resulting portraits, while they *are* portraits, recognisably individual and unique, are at the same time the exploration of a single

11

archetypal image – an image which can seem like a distillation of self, so powerfully does it evoke her own presence.

With another subject-group, the children and young girls who posed for her, mostly in Brittany, around the period 1918–19, there is a further and most poignant illustration of this close interweaving of the image of self and of subject: a photograph of Gwen John herself as a child bears a strange and moving resemblance, in mood and even in posture, to the children of these drawings of her maturity (Fig. 1). It would be wrong to suggest that self-portrayal was, in this context, her conscious aim; but to a remarkable degree it pervades her work, no matter what the style or the medium, and friends acknowledged a dimension of personal involvement in their reaction to her pictures. 'Dear Gwen' wrote Will Rothenstein on the occasion of her London exhibition in 1926, 'you can't think how the likeness of your painting to your own self touches me'; and Michel Salaman, a friend from student days in the nineties, experienced a shock of recognition from the painting he acquired from her in 1925: 'there is so much of the Gwen I know in it that I love having it and want more.'

Gwen John had been born at Haverfordwest in Pembrokeshire in the year 1876. Following the early death of his wife when Gwen was eight years old, her father gave up his solicitor's business and removed with his four young children to Tenby on the coast and it was there that the John children grew up. Nothing in their background or upbringing seems to account for the extraordinary talent of the two middle children, Gwen and her younger brother Augustus. The proficient but quite unoriginal water-colours produced by their mother do not suggest an inherited gift. But it is possible to discover in the fact of her mother's death a source of that passionate melancholy and self-absorption which were to be the hallmark of Gwen John's life. The mother's early death may account also for a streak of stubborn independence shown by all four children who escaped when they could from the atmosphere of stifling respectability which they came to associate with their father – escaped to run wild by the sea and in the beautiful countryside surrounding Tenby.

A periodic need for the sea and the countryside mark Gwen John's entire life. It was not to them that she was eventually to turn for the subject-matter of her pictures, but there is some evidence that, as a subject, landscape did have its place early in her career. A study of landscape had certainly been part of the curriculum of her early learning, first under a series of governesses, later at school. A watercolour landscape, *Shepherd with a flock of sheep*, hung until his death in her father's house at Tenby.

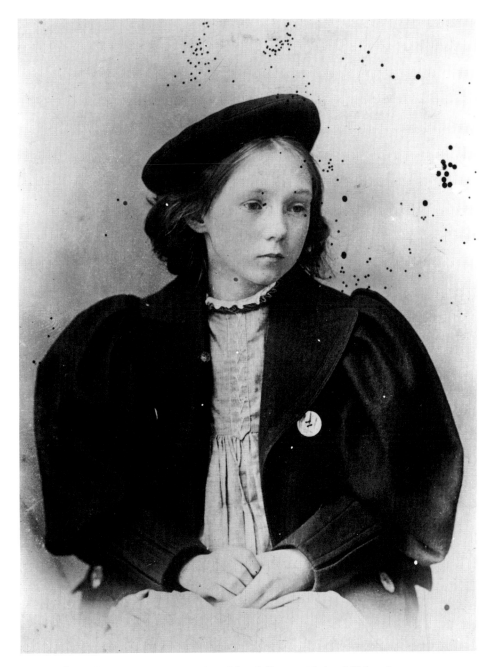

Fig. 1. Gwen John: a photograph of *c*. 1884. Collection Michael Holroyd.

Fig. 2. Augustus and Ida John with David, and Gwen John. A studio photograph of 1902.

According to his housekeeper, he maintained that it was painted by Gwen; and it is signed with her initials GMJ.[1] It seems likely that this is Gwen John's earliest surviving picture, though neither its imagery nor its execution connect it with her later work. Competent and banal, it could have been copied from some schoolroom picture or print (a common enough classroom practice at the time) rather than from nature. Landscape is the ostensible subject of another early picture, *Landscape at Tenby with figures* (Pl. 2). It is later in date than the watercolour and both more awkward and more original. But it is the people in the painting who are the focus of interest. The figure of the little girl is portrayed with an intensity that prefigures the mood of the paintings of Gwen John's maturity. It seems that from around the time of her arrival in London at the age of nineteen to study at the Slade School of Fine Art, portraiture was becoming her main preoccupation.

It was a preoccupation that would have been reinforced and nurtured in the atmosphere at the Slade during the time Gwen John spent there, from 1895 to 1898. One effect of the celebrated emphasis that Slade teaching put on drawing from the life – and drawing moreover with a rapid, free and lively line – was that students felt encouraged to continue the activity of the studios in their lives outside the school. In their various rooms and lodging houses from Gower Street to Fitzroy Square and Charlotte Street they congregated after classes to draw and to be drawn. With her brother Augustus, who had already spent a year at the Slade when Gwen arrived there, she quickly became part of a lively circle of talented friends. Ida Nettleship, Edna Waugh, Ambrose McEvoy, Michel and Louise Salaman, Ursula Tyrwhitt all drew one another or were drawn; and their faces, seen through one another's eyes, and especially through the eyes of Augustus John, are part of our consciousness of that famous epoch in the Slade's history.

The arrival in London of her sister Winifred John, who came up in the autumn of 1897 to study music, meant that Gwen had another important model and one with whom she had already established that special uninhibited rapport that so facilitates the making of a successful portrait. Winifred is the model for the earliest known portrait heads by Gwen John (Pls 1, 4) as well as for many other drawings and at least one other painting (Pls 3, 5, 6, 7).

A few months later Gwen John was in Paris attending the painting

1. Private collection.

sessions at the Académie Carmen (see page 23) under Whistler. Here figure painting predominated once more, though Whistler emphasised that it was not the art of portraiture he was teaching but 'the scientific application of paint and brushes.' During this brief time in Paris Gwen John shared rooms with Ida Nettleship (soon to become Augustus's wife) and Gwen Salmond (who later married Matthew Smith). Ida's letters give vivid glimpses of their life there – a life not so very different from the one they had led in London, with most of their spare time devoted to painting and to posing. 'We all go suddenly daft with pictures we see or imagine and want to do,' Ida wrote to Michel Salaman. The same letter describes Gwen John 'sitting before a mirror carefully posing herself – she has been at it for half an hour. It is for an "interior".' The subject of herself, carefully posed as an item in an 'interior' was one she was to make peculiarly her own.

Over the next fifteen years the self-portrait in one form or another was one of Gwen John's principal subjects. It was with a *Portrait of the artist* that she made her debut at the New English Art Club in the spring of 1900. If this picture was, as seems likely, the *Self-portrait* now in the National Portrait Gallery in London (Pl. 10), it was her first completely assured and confident painting – a masterly summing-up of all she had learned up to this time, with an obvious debt, not only to the Slade, but also to the old masters; and the only one of all her self-portraits whose pose acknowledges and even boasts of the fact that she is her own model. It was followed in the autumn exhibition of that year by the equally assured *Portrait of Mrs Atkinson* (Pl. 9) and by two more portraits in the spring and autumn exhibitions of 1901 (these were *Miss Winifred John* (Pl. 5) and *A portrait* (untraced)). If we are to judge by their titles[2] all but one (the now untraced *April flowers*, shown at the New English Art Club in the spring of 1902) of the fifteen recorded paintings produced between 1899 and 1904 were portraits, two of them self-portraits, and most of the others of sitters who are known to have been Gwen John's close friends. Notable among these was Dorelia McNeill with whom she spent the year 1903–4 in France and who was the model for three of her most moving and assured pictures (Pls 13, 14, 15). But after Dorelia's departure Gwen John found herself alone in Paris earning a precarious living as an artists' model, and soon enmeshed in a traumatic love-affair with the most famous of her employers, the sculptor Auguste Rodin. These circumstances are reflected in the subjects she turned to during the next eight years, from 1904 to 1912. Fastidious

2. As recorded in the catalogues of the New English Art Club and in the catalogue of an exhibition she shared with Augustus at the Carfax Gallery in 1903.

Fig. 3. Gwen John, by Augustus John, *c.* 1899.

17

and passionate, she avoided the ordinary friendships and convivialities of the world of the expatriate painters of Montparnasse who were her main source of employment. She fled from this world each day to the home which, with a kind of painterly discrimination and delight, she created for herself in a modest room in the rue Ste Placide and later in the rue du Cherche Midi and in the rue de l'Ouest. She came to regard her room as a refuge and a consolation, indeed almost as an extension of herself. 'My room is so delicious after a whole day outside', she wrote to Rodin, 'it seems to me that I am not myself except in my room.' Talk of her room and the pleasure and solace she derived from it runs through the letters to Rodin as a constantly joyful theme. It is therefore not surprising to find her room appearing as the subject of more than half of the few oil paintings she completed (only nine have come to light) in the course of her first eight years in Paris. Sometimes the figure of Gwen John herself is part of these pictures – the 'figure doing something' she spoke of in a letter to Rodin (Pls 21, 38, 39); but even when the figure is absent it seems inappropriate to talk of an empty room. I can think of no other painting of a simple interior so powerful in its impact, so tender and intense, so imbued with the spirit of a portrait, as the tiny canvas known as *A corner of the artist's room in Paris* (Pl. 22) which shows the room in the rue du Cherche Midi where Gwen John lived from March 1907 till the autumn of 1909.

During this period, more than at any other time in her life, she made use of herself as a sitter. As well as being the object-figure in some of the room-paintings, she appears as more straightforwardly her own model in a number of other studies: two portraits (Pls 24, 25) and some pencil drawings and gouaches for which she posed in the nude for herself, as she was in the habit of doing daily for her employers (Pls 26, 27). One or two women friends were the subject of portraits (Pls 28, 29, 32, 33, 34); and it was during these first years in Paris that she began to cultivate the habit of drawing in the streets, parks and churches. A cat she acquired in the summer of 1904, a tortoiseshell female which she called Edgar Quinet, was her much-loved companion until its disappearance in the summer of 1908. This cat is the subject of scores of searching and elegant drawings – drawings that are as serious and as important as any Gwen John ever produced (Pls 17, 18, 19, 20). It is possible that she herself was unaware of the extent to which emotional involvement with her subject was, at this stage in her career, a prerequisite of artistic inspiration. But it is characteristic of her that, having once embarked on a picture, it was to formal values that she gave her conscious mind. As she herself was to express it many years later:

'A cat and a man it's the same thing – it's an affair of volumes' (letter to Ursula Tyrwhitt, August 1936).

In 1909 she employed a professional model for the first time – a girl called Fenella Lovell, who also sat for Rodin. The portraits of this model (Pls 30, 31) have a new simplicity and a grandeur of design that is a step towards the monumental images of the later pictures, though lacking their detachment. If anything, Gwen John's response to the sitter's character is more intense than ever in the Fenella Lovell paintings. The driving force in this case was not love or affection but a most profound sense of irritation, which she expressed in her letters to Ursula Tyrwhitt: 'I shall be glad when it is finished,' she wrote, talking of one of these pictures. 'It is a great strain doing Fenella. It is a pretty little face but she is *dreadful*' (30 September 1909).

A new range of subject-matter of a kind which invited a different and more impersonal approach was to be opened up to her as an indirect result of two events that now occurred in her life. The first of these, her removal to live in the suburb of Meudon where Rodin had his home, happened early in 1911. The second was her reception into the Roman Catholic Church in the winter of 1912–13. Increasingly isolated from her few friends and fellow-artists, she became friendly with some of the Dominican Sisters of Charity at Meudon of the Congregation known as the Présentation de la Sainte Vierge de Tours, and sometime during the year 1913–14 she began to paint, at their request, a portrait of their founder Marie Poussepin (1653–1744; Pls 40, 41). Using a number of small reproductions (of the kind found on memorial or prayer cards) based on a portrait belonging to the Mother House of the Congregation, Gwen John set about painting her portrait of Marie Poussepin, recalling perhaps the practice of copying that may have been part of the training of her schooldays. That she felt the task to be a daunting and even a burdensome one is borne out in her correspondence with friends over the next few years. Nevertheless it presented her with a subject whose pictorial possibilities she felt impelled to explore – and to exploit – with all her habitual seriousness, as the resulting pictures testify. To be free of a sitter and of all the attendant distractions and responsibilities may have been a welcome new experience for her as a portrait painter; and the reproduction on a large scale (larger than anything she had attempted until this time) of a tiny monochrome image called for broader handling of pigment which coincided with and reinforced the stylistic development already detectable in the portrait of Chloë Boughton-Leigh (Pl. 35) which had been begun not long before the move to Meudon.

19

Between 1913 and 1921 Gwen John is thought to have painted seven portraits of Marie Poussepin – a number great enough to suggest that it was not just pressure from the nuns (who, she complained, 'wanted one for every room') that kept her working at it, but also her own desire to explore an image which fascinated and moved her. It was an image she continued to explore in another series of portraits – portraits of nuns posed like Marie Poussepin, and dressed in a habit like hers (Pls 42, 43). For the remainder of her career she was to make drawings based on photographs or reproductions found in magazines. Never again however did she succeed in transforming these as she had transformed and appropriated the Poussepin image.

Meudon provided her with other models. Four or five local girls and women inspired a remarkable series of portraits in the years following her move there. Gwen John painted each of these women, as she painted Marie Poussepin, over and over again, seemingly impelled not only by a need to explore and refine the image before her but (to use her own words) to 'fix' it – 'to be sure and certain forever of some ideas in painting.' Not one of these portraits is less than the convincing portrait of an individual, – yet the likenesses blur and merge. It seems appropriate that the identity – and even the number – of the sitters has remained undiscovered.

The periodic visits to the coast that were so necessary to Gwen John's well-being affected her subject matter hardly at all. It is possible that one rare 'subject-picture' was her untraced painting *Les pêcheurs*.[3] A brush and wash drawing of fishermen's baskets was shown (no. 45) in an exhibition held at Faerber and Maison's London gallery in June 1970, and there exists at least one slight pencil drawing of what could be a seaside village.[4] A sketch in oil on cardboard of a house near Pléneuf in Brittany was given by Gwen John to its owners, the Lesage Family, in 1919 and belongs to a member of that family still. With its rough and uncoordinated handling of paint, this picture is uncharacteristic, in spite of its sensitive colour. It is one of the very few of her paintings that appear to have been dashed off without concentration and commitment. It seems that the coasts and villages of Brittany and Normandy with their picturesque inhabitants, so popular a subject among artists, did little to inspire her. What has come to be thought of as Gwen John's 'Brittany' work consists of some scores of drawings of about a dozen children – children whose portraits she drew in

3. Exhibited (no. 30) New English Art Club, summer 1910, and sold from that exhibition. Dimensions unrecorded.
4. Collection National Museum of Wales.

Brittany but who could have belonged to any place or background (Pls 56, 57, 58, 59).

Since Gwen John's early years in Paris, the churches had provided her with a convenient shelter and drawing place. Following her conversion to Catholicism figures in church were an obvious source of material for her pictures. There are more drawings of people in church than of any other single subject. The church pictures reflect the circumstances of their production. They are small in scale – small enough to have been drawn on the pages of pocket sketch-books – and most are done in watercolour or gouache over an underdrawing in pencil or, occasionally, charcoal. It seems improbable that she would have encumbered herself in church with the paraphernalia of the watercolour artist and the pictures themselves suggest that the colour was added in the studio. Almost every subject is repeated several times over (in some cases more than a dozen times). Sometimes there is only the slightest of variations between one of these repetitions and the next; at other times the repetitions incorporate important changes in tone, in colour, and in composition. In other words, many of these little pictures, for all their lively observation of fact, are reflective experiments in form and structure. In some of the church pictures the image has become so condensed and refined that its subject seems to be the *idea* of the figure depicted, rather than the figure's physical reality (Pl. 69).

Gwen John died in 1939 at the age of sixty-three, but sometime around the early 1930s she ceased to paint or even to draw. It is known that general ill-health afflicted her in later years and that her eyes were increasingly troublesome. During the last decade of her life she devoted herself more and more to the garden of a little chalet she had had built for herself on a piece of land surrounded by tall trees in the rue Babie at Meudon. In the course of her years at Meudon she had turned again to landscape and to flowers, both of which had been the subject of some of her earliest paintings. There is some evidence that a landscape was among her last pictures (Pl. 71). But it was with the subject of flowers that she was at her most abstract and experimental. Hundreds of studies in various media whose subject was flowers and flower-vases were found in her studio after her death.[5] They range from the finely representational to the boldly stylised. Some of the latter are so simplified that they have become almost meaningless except as picture pattern. And as her life advanced, the subjects that appealed to her were themselves things of ever greater simplicity and

5. Many of these are now in the collection of the National Museum of Wales, others are among her notes and letters.

anonymity. One day towards the end of her life her nephew Edwin was walking with Gwen John in her garden. He heard her say 'Now there's a subject. One could make a painting of that.' Turning to her, he found that she was looking at a leafless twig.

Three phases are distinguishable in Gwen John's career as an artist. From the first of these, roughly the years 1891–99, her adolescent and student years, very little has survived, though she is known to have devoted herself with increasing singlemindedness to the activity of drawing and painting from the age of fourteen or fifteen. The dearth of early work by Gwen John – and also by Augustus – is explained in a story told by their father's house-keeper Miss Elizabeth Davies. Following the death of old Mr John in April 1938 Augustus John arrived in Tenby to deal with his father's estate. In the course of clearing the house he systematically destroyed quantities of paintings and drawings, including pictures by his mother, by himself and by Gwen. That this wholesale destruction of his sister's early work was carried out in a spirit of homage there can be no doubt, for from early times, Augustus had been one of the staunchest admirers and promoters of her work; and it was an action of which she, if she knew of it, would certainly have approved. And it was in fact thanks to Augustus that three of Gwen John's known oil paintings from the early period have survived: the portrait of Winifred John (Pl. 1) was given by him to Miss Davies; the *Landscape at Tenby* (Pl. 2) and the portrait of Grace Westry (Pl. 8) were preserved by him and remained in his possession for the rest of his life. The survival of the fourth painting from this early period – Gwen John's student copy of the National Gallery's *The duet* by Gabriel Metsu – as well as the preservation of the early drawing of Winifred John (Pl. 4), seem also to have been due to Augustus.

From these five pictures can be gleaned some idea of Gwen John's early explorations and experiments as she struggled to find a language. The vigorous *alla prima* treatment of the Winifred portrait and parts of the Tenby landscape (the technique Augustus used later with such panache), is eventually abandoned as she moves towards the use of fluid semi-transparent paint, thinly applied with a sable (cp. Pls 1 and 8) and the Tenby landscape, whose dream-like vision suggests a memory-picture, illustrates her willing-ness to explore a wider range of subject-matter than is generally associated with her. There is little that is tentative about the early drawing of Winifred (Pl. 4). Its confidence and fluency reflect the atmosphere at the Slade where drawing was taught with a seriousness and enthusiasm which the teaching

22

of painting there in the nineties never seemed quite to equal. Drawing at the Slade, far from being the mere laborious recording of form by means of light and shadow, was held to be a language in its own right, and to the end of her life that was how Gwen John thought of it.

By some of her student contemporaries she was soon considered to have achieved an understanding of paint which they felt that teaching at the Slade had failed on the whole to provide. Edna Clarke Hall on leaving the Slade placed herself for a time under Gwen John's tutelage. From their painting sessions together she remembered above all Gwen John's insistence on a clean and orderly palette, her exacting attention to the rightness of tones – particularly in transitional passages – and her repeated instruction 'If it isn't right, *take it out*!'[6]

These lessons probably took place soon after Gwen John's return from her first visit to Paris where for a few brief months in the winter of 1898–9 she attended the short-lived Académie Carmen where Whistler made occasional appearances as the main visiting instructor. Orderliness and method and an emphasis on 'good habit' were what Whistler preached to his students. The palette was to be set out according to an invariable rule which he dictated, and the colours were then to be mixed and graded to form 'a systematic transition from light to dark: quite as definite a sequence as an octave on the piano.'[7] He insisted that no painting on the canvas should be begun until the student was satisfied that every decision regarding tone and colour had already been made on the palette. Only then, and using a separate brush for each 'note' in the sequences now arranged before him, was the student permitted to transfer paint to canvas. Gwen John allowed herself to be influenced at first only by those aspects of Whistler's teaching (in this instance the notion of order and discipline and a concern with the understanding of tone values) which were immediately useful to her. She held in reserve other aspects of what she had learned. It was not until a much later time that she began to make use of a painting method very like

6. Interview with the author, 7 June 1974. Edna Waugh, who later married (Sir) William Clarke Hall, was fifteen years old when she arrived at the Slade the year before Gwen John. Before long she was being spoken of as a kind of infant prodigy and classed with Augustus John and William Orpen as one of the Slade's most brilliant students. Augustus's opinion of her as a draughtsman, given many years later to a potential buyer, was 'Good. Damned good. Always was.'
7. 'Reminiscences of the Whistler Academy. By an American student' (Mary Augusta Mullikin). *The Studio*, xxxiv (1905) pp. 237–41. Whistler's teaching method is described in detail by Miss Inez Bate (Mrs Clifford Addams) in *The Life of James McNeill Whistler* by E. R. and J. Pennell, Heinemann, London, 1908. Vol. 2, pp. 230–38.

the one Whistler had prescribed. The work she produced soon after her return to London in 1899 is done in an idiom far removed from Whistler's painting; it seems instead to reflect her studies in the Louvre and the National Gallery. But it has about it a striking new confidence and maturity. The *Self-portrait* (Pl. 10) which dates from this period (when she was twenty-three years old) is as masterly as any picture she would ever paint. It marks the beginning of her first mature phase – a phase which lasted until about the year 1912.

In spite of the confidence with which she began this phase of her painting career (within six months of the exhibiting of her *Self-portrait* at the New English Art Club in the spring of 1900 the equally powerful portrait of *Mrs Atkinson* (Pl. 9) was shown there) Gwen John's output of paintings over the next dozen years was not prolific;[8] and there is some evidence that the paintings she produced in the course of the first few years of the century were far from being the product of some infallible new facility. These years were a time of struggle and failure as well as of great achievement. In the spring of 1902, at the very moment of completing one of her finest pictures (the Tate Gallery's *Self-portrait* (Pl. 11)) she submitted a painting to the New English Art Club which was judged by one reliable critic to be 'very weak and bad'.[9] She is known to have found the pressure to submit pictures to the Club's twice-yearly exhibitions an inhibition rather than a stimulus, and this pressure may have contributed to what seems at times to have amounted to a positive reluctance to paint at all, in spite of the encouragement of her friends and fellow-artists. These included Professor Frederick Brown, who had been one of her teachers at the Slade and who bought her second *Self-portrait* as soon as it was exhibited (see note to Pl. 11), her close friend Michel Salaman who gave her both moral and material support, and his sister Louise, another enthusiastic buyer of her work. She also had the admiration of Augustus (whose opinion she sometimes felt was of oppressive importance to her) who by the early years of the century had already established his own substantial reputation. He persuaded her to hold a joint exhibition with him at the Carfax Gallery in March 1903. The catalogue lists forty-eight exhibits – paintings, pastels, drawings and etchings. Three of them were by Gwen. Of these, one was apparently withdrawn before the opening day. Augustus reported to Will Rothenstein: 'Oh, yes Gwen has the honours or *should* have – for alas our smug critics don't appear

8. Twenty-three finished paintings have been recorded for the years between 1900 and 1912.
9. William Orpen in a letter to Albert Rutherston, early summer 1902.

24

to have noticed the presence in the Gallery of two rare blossoms from the most delicate of trees. The little pictures to me are almost painfully charged with feeling; even as their neighbours are painfully empty of it. And to think that Gwen so rarely brings herself to paint!'[10] A few weeks later Augustus was further enraged when the hanging committee of the New English Art Club rejected the pictures submitted by his sister to the spring exhibition.

That summer Gwen John set off, accompanied by her friend Dorelia McNeill, on a walking tour of the Continent. This was to be a decisive event in her life. The girls intended to walk to Rome but they only managed to reach Toulouse and eventually returned to Paris in the spring of 1904. Paris was thenceforward Gwen John's permanent home. The practical difficulties she faced there as a single woman earning her living and at the same time struggling to maintain her life as an artist were hardly greater than those she had already encountered living alone in London; and by moving to Paris she escaped, not only from the overpowering influence of Augustus, but also from the curiously vapid atmosphere of the English art world of the day. At the same time she found herself close to the centre of most of the vital and innovative thought affecting the visual arts in Europe. Gradually, without attaching herself to any school or movement, she was to allow herself to absorb this influence.

The immediate results of the 'walk to Rome' were the group of portraits of Dorelia (Pls 12–16) which were made at Toulouse where the girls spent the winter of 1903–4. Technically the Dorelia paintings (like Gwen John's two earlier self-portraits) owe much to her friend Ambrose McEvoy, who had imparted to her the results of his painstaking studies of the methods of the old masters. Titian, Rubens, Rembrandt, Claude, Gainsborough and Hogarth are among the chief names in the notebooks containing his observations made in the National Gallery and the Soane Museum. Gwen John's portraits of this period are done in her own version of an 'old master' technique. On a canvas part-tinted with umber over a white priming, the picture is built up in states each of which is allowed to dry before the next application of paint. The paint is kept thin and fluid; and the vivacious drawing of detail with a fine sable is done in an idiom reminiscent of some of her drawing in pencil. A final strengthening of form is frequently made

10. William Rothenstein: *Men and Memories: Recollections 1900–1922*. London, 1932, p. 65. The three paintings listed in the Carfax catalogue are: *Portrait, Miss Louise Ethel Jones-Lloyd*; *Portrait, Miss Ursula Tyrwhitt*; *Alladine and Ardiane*. The present whereabouts of all three is unknown.

by the addition of the most delicate glazes put on with great boldness and assurance. The assurance and serenity of the Dorelia portraits are at odds with the account of their creation in Gwen John's letters to her friend Ursula Tyrwhitt, which conveys an impression of prolonged and exhausting effort. 'A week is nothing', she wrote, 'one thinks one can do so much in a week. If one can do a square inch that pleases one, one ought to be happy.'

The scarcity of paintings over the next seven or eight years can be accounted for partly in terms of this exacting perfectionism. But it reflects also the circumstances of her life. Earning her living in Paris as an artists' model, she was employed by Auguste Rodin[11] and fell passionately in love with him; and although, after they had become lovers in the summer of 1904, he augmented her meagre earnings by paying the rent of her lodgings, she was still obliged to spend the greater part of each day working or seeking work. The few paintings she did manage to produce themselves reflect her way of life – and not only in the autobiographical nature of their subject-matter. The rooms she lived in were neither large nor well-lit and even her easel seems to have been the small folding one she had carried with her from England. These factors must explain, to some extent at least, the minute scale of most of the paintings she produced between 1904 and 1912.[12]

Neither the emotional turmoil nor the material hardship of these years prevented her, however, from producing a quantity of important drawings. Drawing had always been for her an activity of the utmost seriousness and one which she considered in no way subsidiary to the act of painting. Few, if any, of her drawings can be seen as studies for paintings, even when they represent a subject of which painted versions also appear; and many of her drawings have a grandeur and a power which equal anything she did in paint. She herself seems to have seen them as setting some kind of standard. 'Paint as you do your drawings' is one of the numerous random self-exhortations which crop up among her written notes. The act of drawing came to be bound up with her very sense of psychological well-being and even with her physical health. A letter (undated) to Rodin describes how, ill and restless, she went out into the streets of Paris, to the gare Montparnasse and in and out of some of the nearby churches, trying

11. Rodin made several head-studies of Gwen John, and she was the model for his *Monument to Whistler*, begun in the summer of 1905 and continued at intervals until about 1914, but never completed.
12. The portraits of Miss Boughton-Leigh, which are on a somewhat larger scale, seem to have been painted – or at least begun – in Miss Boughton-Leigh's flat in Paris.

26

to find subjects for drawings. 'It seemed to me my spirit had a need to draw', she wrote. 'I would feel better if only I could draw something well.'

It is in her drawings that there first appears that feature of her work which so distinguishes the last phase of her life as an artist – the pictures done in series or sets. As early as 1903–04 drawings of Dorelia are repeated in almost identical versions as if from a desire to explore and re-explore a compelling image. Later repetitions of various drawn subjects are done for other reasons. Some of them are made very carefully (and to some extent mechanically) as part of a deliberate scheme of controlled experiment with the medium of gouache (Pls 27, 37 and notes). Repetitions such as these are not to be found in Gwen John's early paintings. In these paintings a tendency towards repetition manifests itself in another way – the production of pairs of pictures, the second picture in each pair exploring a slightly different aspect of the potential of the first (Pls 13, 14; 22, 23; 30, 31; 38, 39). In the beautiful and mysterious second version of the *Corner of the artist's room*, for instance, there is a shift towards an emphasis on the picture's rectilinear design; the second portrait of Fenella Lovell, with its elongations and distortions, seems to be exploring with heightened emotion a concept deriving from the first. It is not until about 1913 that sets of pictures in the medium of oil begin to make their appearance. This marks the beginning of the third phase of Gwen John's career. From this time onwards it is rare to find her working on any picture, either painted or drawn, that is not part of a set.

The first of the important sequences in paint – the portraits of Marie Poussepin – has an obvious starting-point in the nuns' request for several portraits of their founder. But the request seems to have coincided with and reinforced Gwen John's own need to explore and re-explore a subject by means of repetition. When she makes an attempt to explain this practice of repeating an image, her words carry little conviction, as if she feels herself both obliged to account for it and unable to do so. Writing to Dorothy Samuel, who had just bought a version of *The convalescent*, she says (31 December 1925): 'I have sold two studies for it and I have one or two more. I hope this will not make you value your picture less. Please, if you write again to me, tell me. I always do about five studies for a picture but I am going to change that system and do new things and try not.' The last three words are then crossed out and on that uncertain note the sentence ends: indeed after this date Gwen John's habit of repeating a subject did not diminish, and sketches in her notebooks show that it eventually became more like a compulsive habit than part of a truly creative process. In spite of

Gwen John's use of the word 'studies' it is difficult to single out, in the sequences, pictures which can with confidence be called preparatory, or given subsidiary status. Perhaps each set of pictures should be seen as a single portrait, a simultaneously evolving image. Gwen John herself refers in the singular to her paintings of Marie Poussepin, calling them 'the nun' or 'my nun'.

The creation of the sets of pictures can be associated also with the dramatic change of painting technique which is another mark of this third phase of Gwen John's career (see Pl. 35 and note). The new, direct technique, unlike the earlier indirect one, could seem to demand that a picture be done quickly. 'A picture ought to be done in one sitting or at most two' she wrote to Ursula Tyrwhitt. 'For that one must paint a lot of canvases probably and waste them' (3 August 1916).[13]

The new technique is almost exactly the opposite of the earlier one. The liquid films of paint are replaced by an impasto of opaque chalky pigment directly applied in mosaic-like touches to canvases often so thinly primed as to be dangerously absorbent. The close range of subtly graded tones and colours suggest that Gwen John was now working with paint mixtures systematically and thoroughly prepared on the palette, in a manner resembling the one prescribed by Whistler.[14] Unfinished canvases show large and important areas left blank as if, already part of a final image clearly planned and visualised, they only await completion with the appropriate finely-judged colour-mixture (Pl. 49). What this technique has in common with Gwen John's earlier one is its foundation on order, discipline and a systematic method. Though, in the period 1910–14, her letters indicate that she felt the need to reappraise her approach to painting, she never wavered in her belief that order, method and concentration, which had been the foundation of her achievement up to this time, were the first prerequisite of good work. A letter to Ursula Tyrwhitt contains a clear statement of her beliefs: 'You say you have done bad pictures and feel very unhappy. I don't think you ought to be discouraged – your paintings will always mean a great deal, there is such a distinct personality in them. If you want them to be better in technique you have only to occupy your thoughts a little

13. Gwen John did not adhere strictly to this rule. Many of her portraits of this period took much longer than two days to complete, and she is known to have returned to work on paintings which had been abandoned.
14. Gwen John made use of the Whistler method in her own idiosyncratic way. The touches of thick chalky pigment are quite different from the paint 'put down with a generous flowing brush' normally associated with his teaching.

more on the rules or problems of painting. I cannot help thinking it is a great pity you don't think about such things more. I feel as if you could do anything if you would only concentrate your thoughts. I don't know if you would do in a very short time better work than you have – but in a long time you would & in the meantime do as good I think, & without so much *chance* in the doing of it . . . As to me, I cannot imagine why my vision will have some value in the world – and yet I know it will . . . I think it will count because I am patient and recueilli [contemplative] in some degree –but perhaps I am boasting even in that – indeed I think I am, somewhat' (4 February 1910). A large part of Gwen John's written notes is taken up with her own lists of rules and injunctions. Many of them could apply quite as much to the regulation of her life as to the organisation of her painting. Some take the form of a systematic catechism of questions and answers which seems to derive from the kind of programmed self-examination that would have been part of her religious training. Others are more specifically concerned with the making of pictures. For the identification of tones she had devised a system based on the numbers 1, 2 and 3 in various combinations, and painting subjects are listed in the notes, together with their appropriate tone values. But her notes are far from being coldly schematic. They have a poetic allusiveness and, with their mixed French and English, their references to flowers and plants, their juxtaposed directives and descriptions, they conjure up with extraordinary vividness her pictures and her personality. Some typical extracts read: 'April. faded panseys on the sands at night. Tones. sky 22 clouds 13 house and bushes and grass 23 & 13 road 32 people 33.'; 'March 1923 Colour harmony:— Elder-berries & their yellow leaves & pink campiens & their cendre bleu green leaves.' A list headed 'The making of the portrait' begins '1. The strange form 2 The pose and proportions 3 The atmosphere and notes 4 The finding of the forms'; and another: 'Method of observation: 1 the strange-ness 2 colour 3 tones 4 form'.

This insistence on the idea of 'strangeness' seems to link Gwen John to the painting of an earlier time – the last two decades of the nineteenth century and to painters connected with the Symbolist movement and their preoccupation with allusion and mystery. Gwen John's words 'the strange form' are like an echo of the words used by those painters in their attempts to define what was central to their art: Maurice Denis and his 'Idea within nature', Sérusier's 'mental image', Gauguin's 'mysterious centre of thought' which seemed to him so absent from the work of the Impressionists. To claim that Gwen John was influenced by these men would probably be

29

to exaggerate. But it is typical of her that, so many years after their heyday, she should express an attitude so similar to theirs with so much simple conviction and so little self-consciousness. Some of her pictures themselves, with their figure-containing outline and undulating pattern, bring Symbolist-related work to mind and seem to hark back to the painting of Puvis de Chavannes, whom she is known to have revered (and even, through him, to Ingres) (Pls 35, 39). When, in 1926, she was persuaded to put on in London the only exhibition of her work to be held in her lifetime, she chose as a preface to the catalogue one of the *pensées* of Maurice Denis: 'I have always had the wish to organise my work, my thought, my life and, as Cézanne said, my *sensation*. The power to suggest connections between ideas and objects has always been the point of art.'

Gwen John never attached herself to any school or movement but her written notes and letters bear witness to a generous and open-minded delight in the work of other artists. The names she praises range from Fra Filippo Lippi to James Ensor, from Rouault and Chagall to Piero di Cosimo; and it is possible to detect, absorbed into her art, the influence of a multitude of predecessors and contemporaries. Her notes and letters also convey a sense of unceasing endeavour and a lifelong desire to learn and to improve. As early as 1904, when the Dorelia portraits were nearing completion, the satisfaction she felt seems to have come (as she told Ursula Tyrwhitt) from having, in the process of creating them, 'discovered a few little things about painting' (undated letter, spring 1904). During the 1930s she became increasingly interested in Cubism and found herself in particular sympathy with the theories of André Lhote. At the age of sixty (three years before her death), still pursuing the means to resolve what she called 'problems of technique', she set herself a course of study and, though frequently unwell, attended Lhote's famous classes for a time in the summer and autumn of 1936. Some of her last letters to Ursula Tyrwhitt discuss his teaching: 'I learnt so much at these visits' she wrote. 'He is such a good artist . . . Ill or well I shall go again in October.'

Plates

sizes are given in inches, followed by
centimetres in round brackets

Many of Gwen John's pictures have appeared at different times under
varying titles. In an attempt to establish titles for the pictures in this book,
I have observed the following guidelines: if an established and commonly-
held title exists, I have chosen it in preference to any other, even if it
appears to be descriptively inaccurate (e.g. Pl. 7) and even if it differs from
the title given by Gwen John herself. When a picture has no established
title, or when it has been listed or exhibited under a number of different
titles, I have opted for the one given to it by Gwen John if that is known.
On occasion I have added two or three words of description to a title in order
to distinguish it from another which is identical (e.g. Pls 22, 23).

With the exception of one early watercolour (see p. 15) and the Tate
Gallery's *Self-portrait* (Pl. 11) (both of which bear her initials GMJ) Gwen
John's pictures were never signed. The signature which appears on many
of the drawings is a facsimile stamp authorised by her executors in the
middle 1940s and used by the Estate since that time.

Gwen John never dated her work. The numbers which appear on some
of the drawings (not included in this book) and which could be mistaken
for dates are in fact tone references. Many of the drawings given by Gwen
John to her friend Véra Oumançoff in the late 1920s and early 1930s bear
the date of presentation (usually inscribed on the mount). These dates
generally bear no relation to the date of execution.

Throughout the book the word 'painting' refers to a work done in the
medium of oil. Gouaches and watercolours have been called 'drawings'.

M.T.

1. Winifred John
 1896–7, oil on canvas. 10 × 8 (25.5 × 20.5)
 Tenby Museum

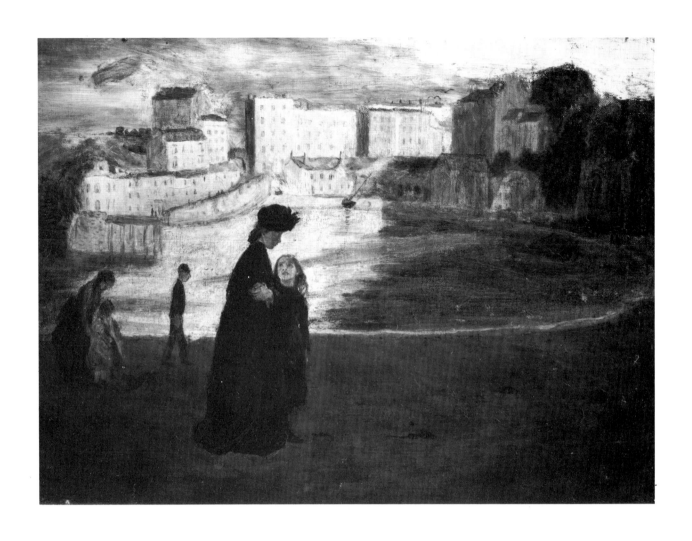

2. Landscape at Tenby, with figures
1896–7, oil on canvas. 12 × 15 (30.5 × 38)
Private collection

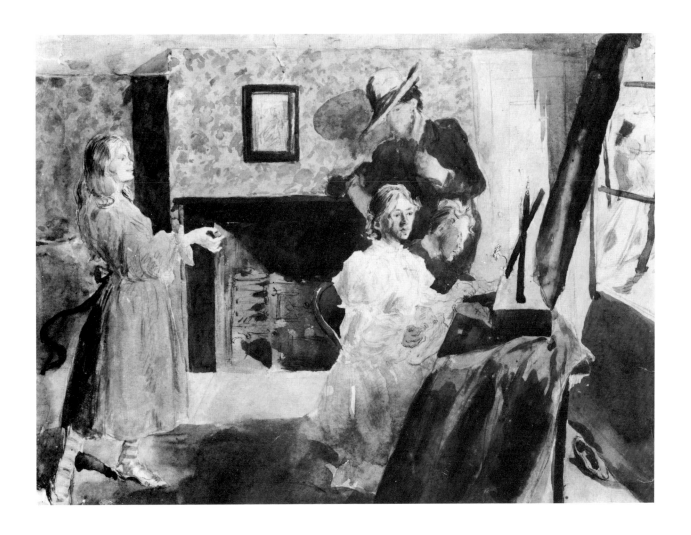

3. A group of students
 c. 1898, pencil and watercolour. 11 × 15 (28 × 38)
 Private collection

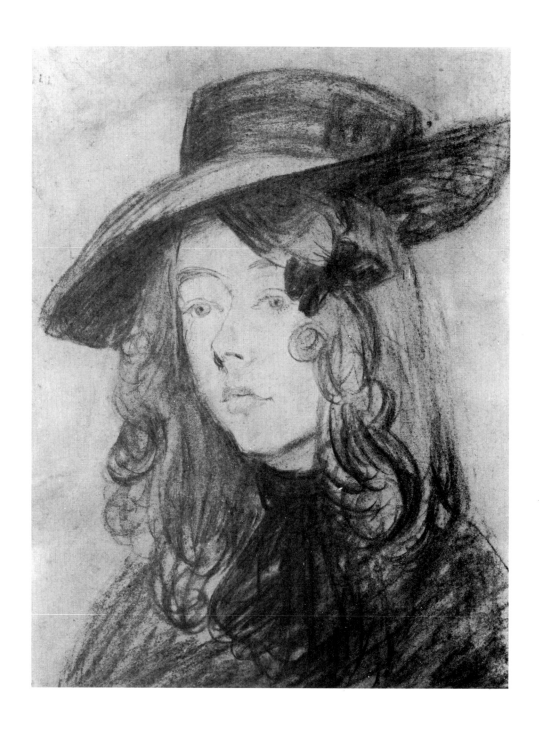

4. Winifred John in a large hat
1896–7, charcoal. $12\frac{1}{4} \times 9\frac{1}{2}$ (31×24)
National Museum of Wales

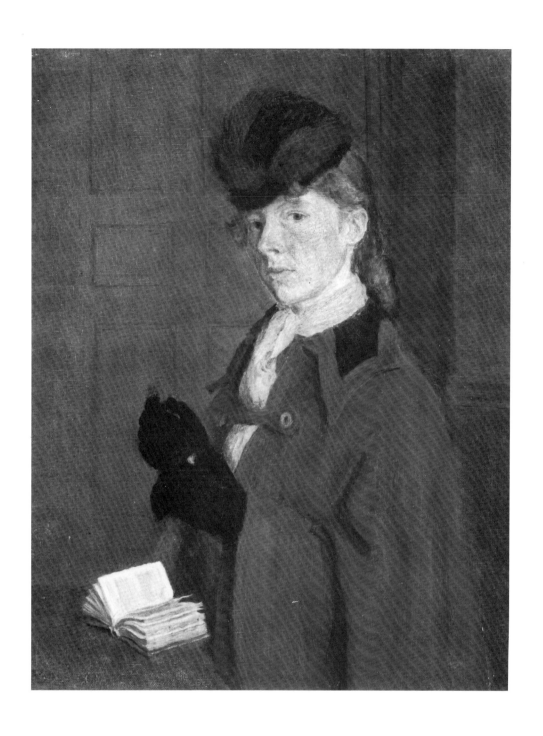

5. The artist's sister Winifred
c. 1899, oil on canvas. 18 × 16 (45.5 × 40.5)
Private collection

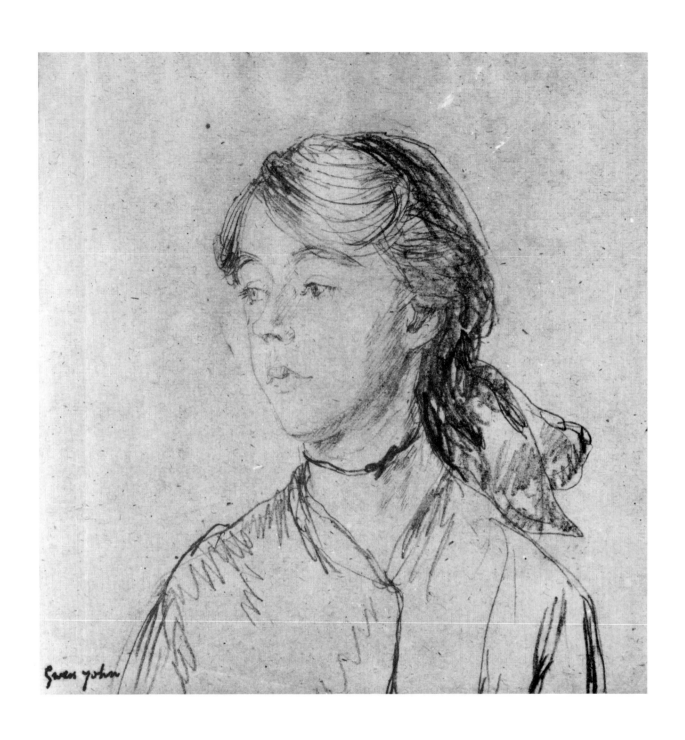

6. Half-profile of Winifred John

c. 1907, pencil. $6\frac{1}{4} \times 6\frac{1}{4}$ (16 × 16)
Sheffield City Art Galleries

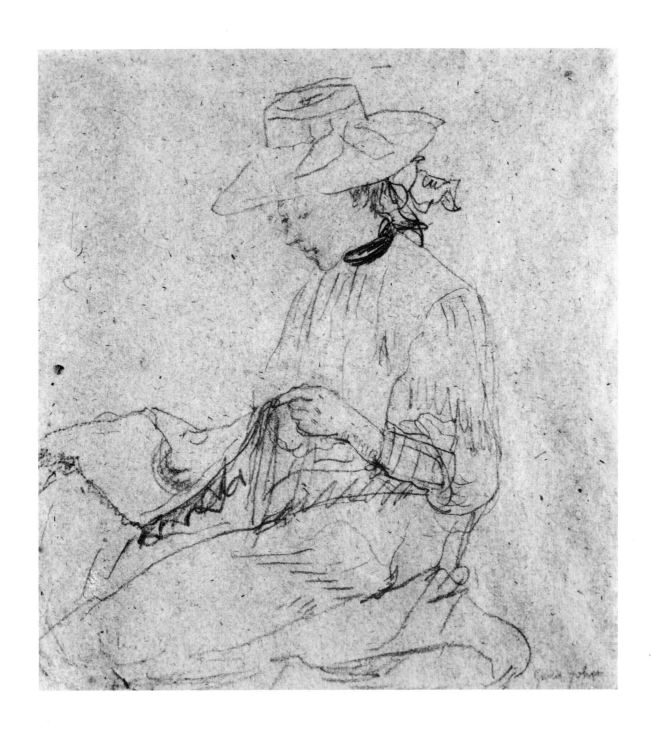

7. **Young woman sewing, sitting on the ground**
1898–1903, pencil. $6\frac{7}{8} \times 6\frac{1}{4}$ (17.5 × 16)
Birmingham Museum and Art Gallery

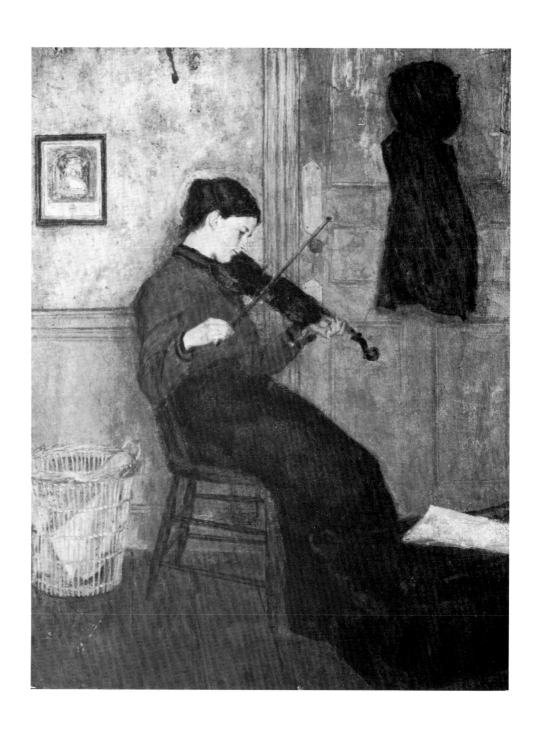

8. Grace Westry with a violin
1897–9, oil on canvas. 18 × 16 (45.5 × 40.5)
Private collection

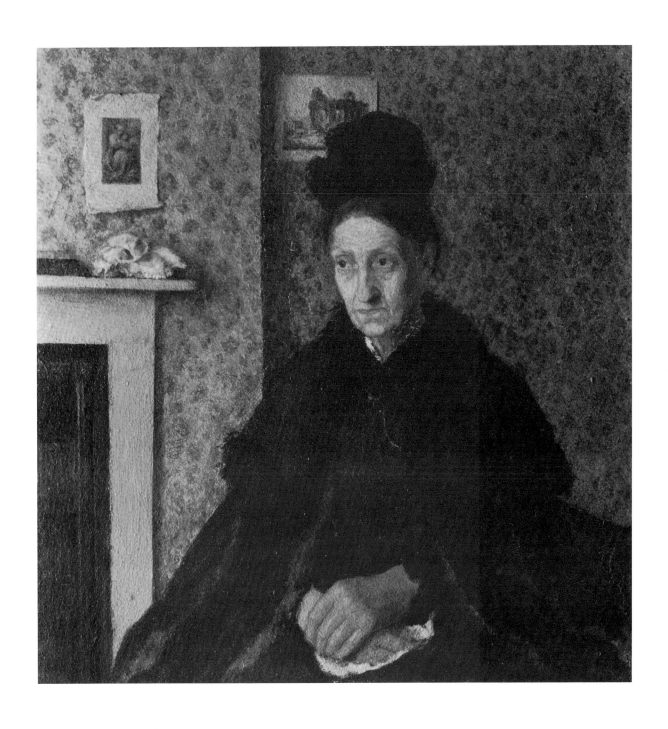

9. Mrs Atkinson
 1899–1900, oil on panel. 12½ × 12½ (32 × 32)
 Metropolitan Museum of Art, New York

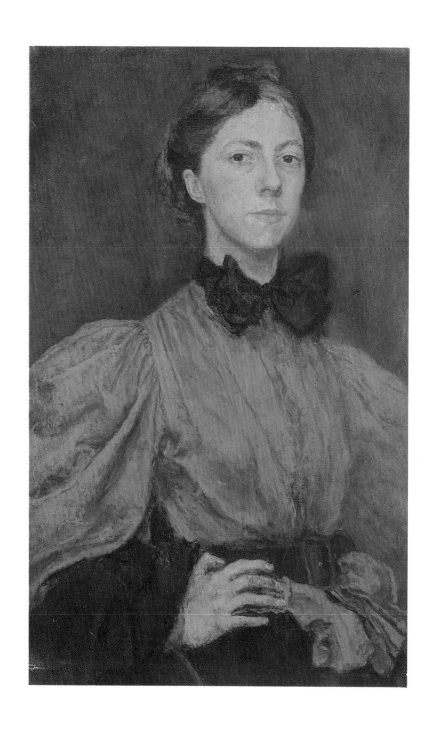

10. Self-portrait
1899–1900, oil on canvas. 24 × 14⅞ (61 × 36.5)
National Portrait Gallery, London

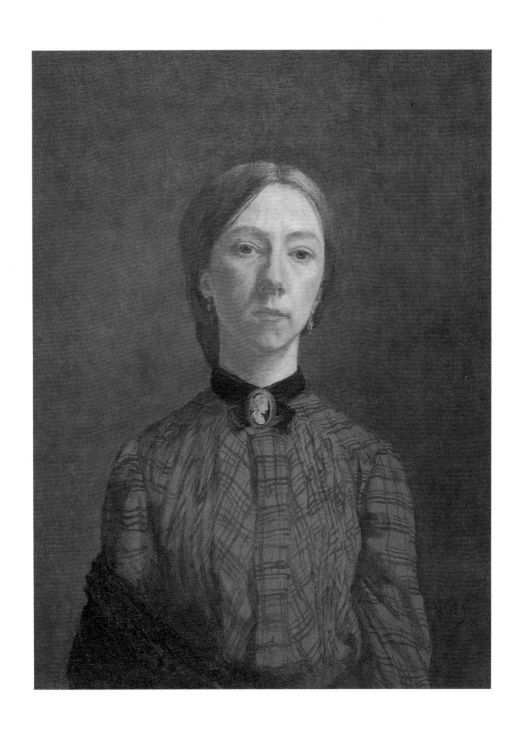

11. Self-portrait
 1902, oil on canvas. 17⅝ × 13¾ (45 × 35)
 Tate Gallery, London

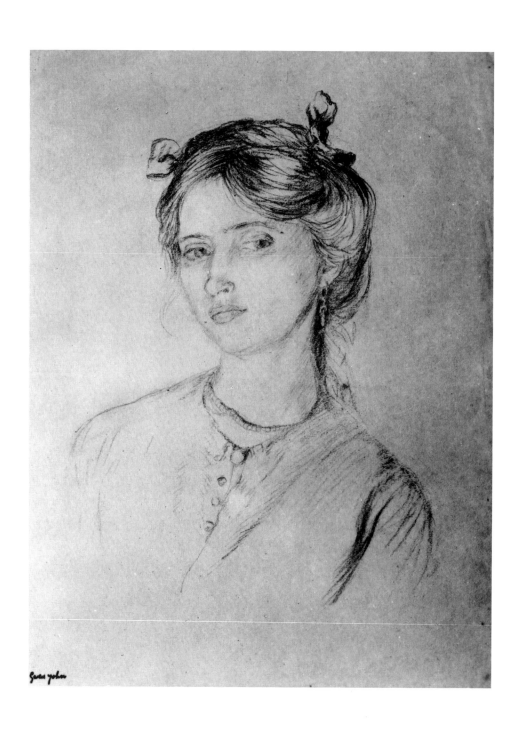

Gwen John

12. Dorelia with bows in her hair
1903–04, red chalk. $12\frac{3}{4} \times 9\frac{7}{8}$ (32.5 × 25)
Private collection

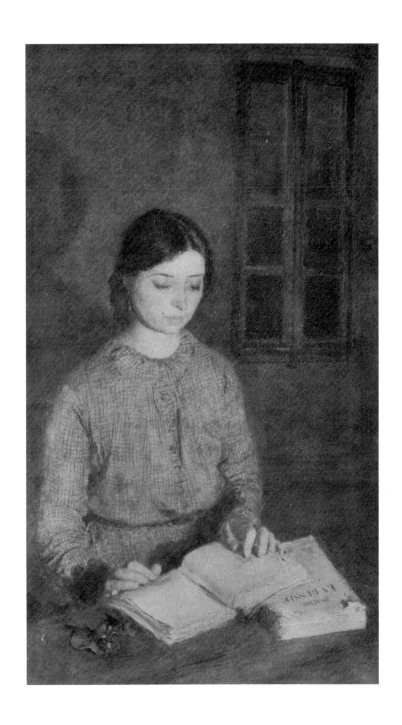

13. Dorelia by lamplight at Toulouse
1903–04, oil on canvas. 21½ × 12½ (54.5 × 32)
From the collection of Mr and Mrs Paul Mellon, Upperville, Virginia

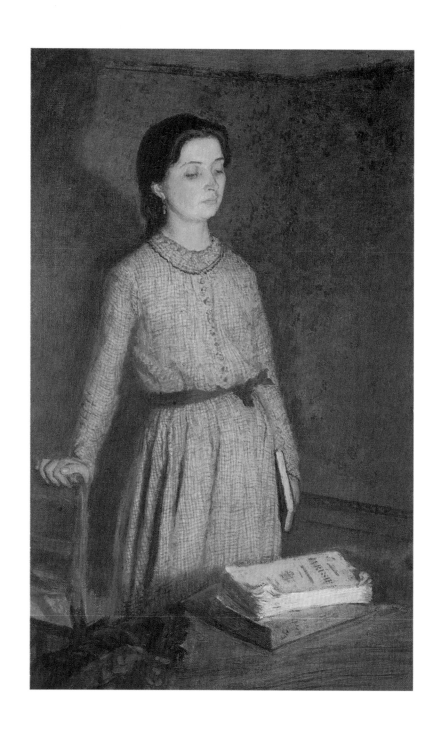

14. The student

1903–04, oil on canvas. $22\frac{1}{8} \times 13$ (56×33)
City of Manchester Art Galleries

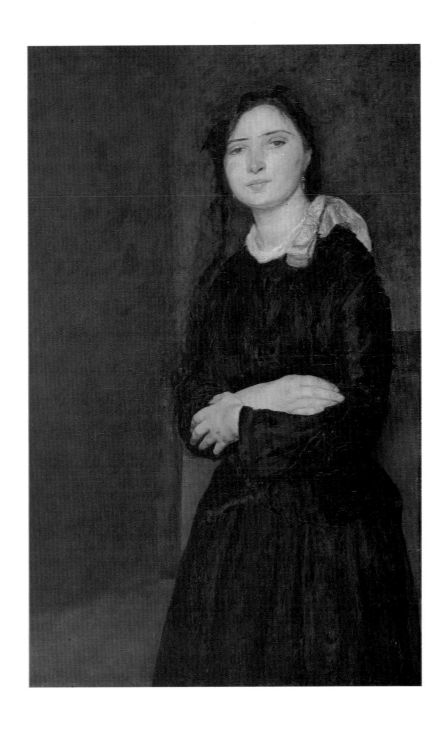

15. Dorelia in a black dress
1903–04, oil on canvas. 28¾ × 19¼ (73 × 49)
Tate Gallery, London

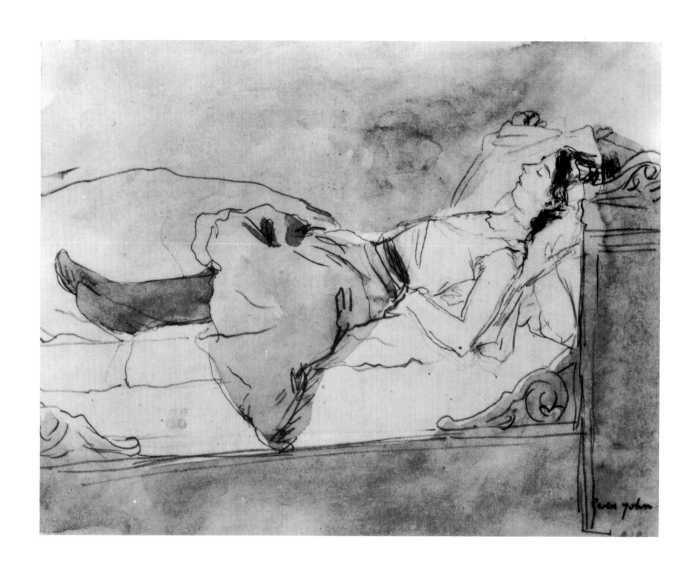

16. Woman asleep on a sofa
1903–04, pencil and wash. $6\frac{1}{8} \times 7\frac{7}{8}$ (15.5 × 20)
Private collection

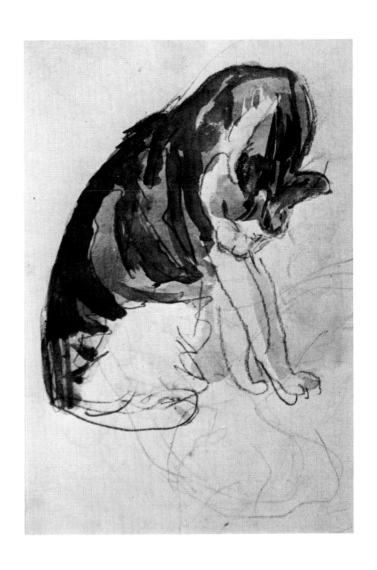

17. Cat cleaning itself (Edgar Quinet)
1904–08, pencil and watercolour. $6\frac{1}{2} \times 4\frac{5}{8}$ (16.5 × 11.5)
Tate Gallery, London

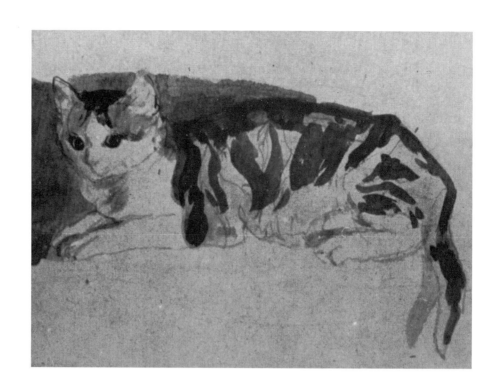

18. Cat looking alert (Edgar Quinet)
1904–08, pencil and watercolour. Dimensions unknown
Whereabouts unknown

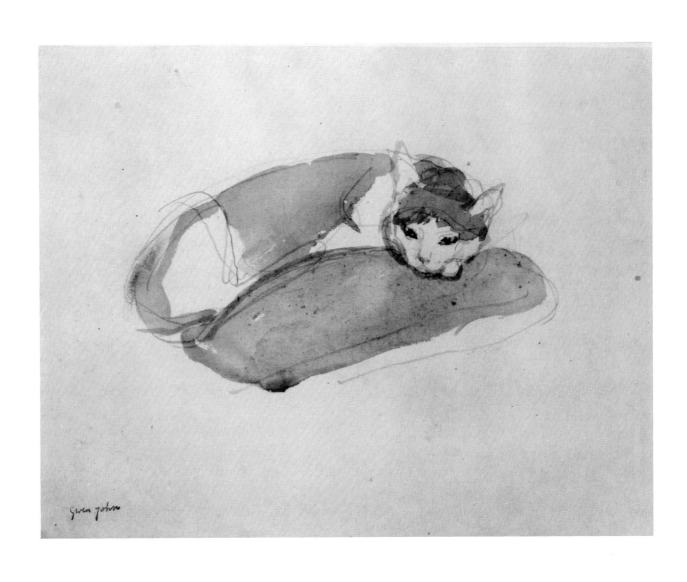

19. Study of a cat (Edgar Quinet)
1904–08, pencil and watercolour. $7\frac{1}{4} \times 9\frac{1}{2}$ (18.5 × 24)
Formerly collection Mrs Reine Pitman

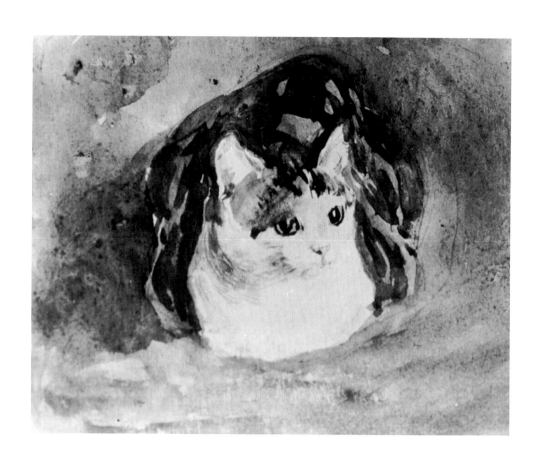

20. Cat (Edgar Quinet)
 1904–08, pencil and watercolour. 4⅜ × 5⅜ (11 × 13.5)
 Tate Gallery, London

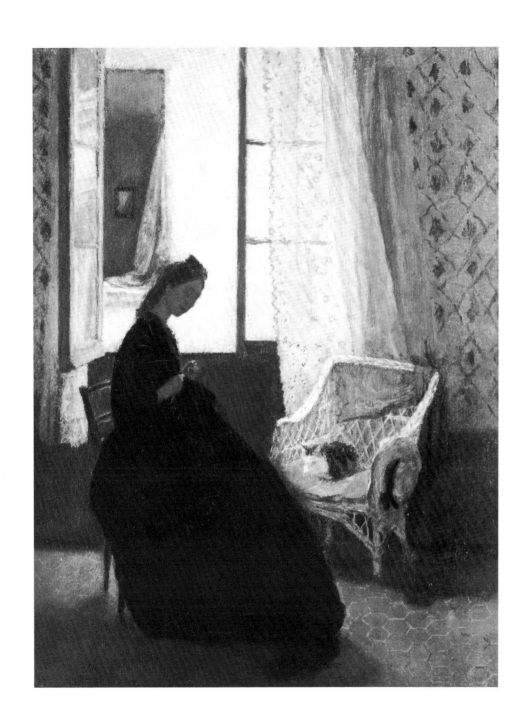

21. La chambre sur la cour (Girl sewing at a window)
 1905–06, oil on canvas. $12\frac{1}{2} \times 8\frac{1}{2}$ (32 × 21.5)
 Private collection

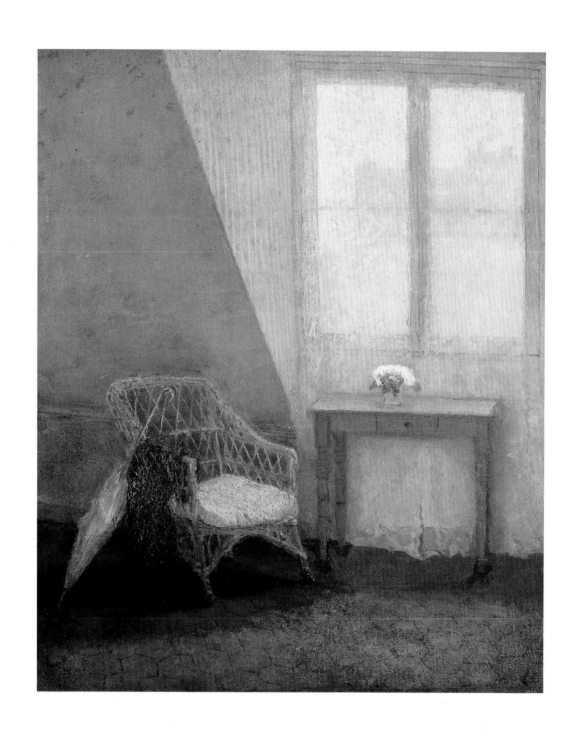

22. A corner of the artist's room in Paris (with flowers)
1907–09, oil on canvas. 12½ × 10½ (32 × 26.5)
Sheffield City Art Galleries

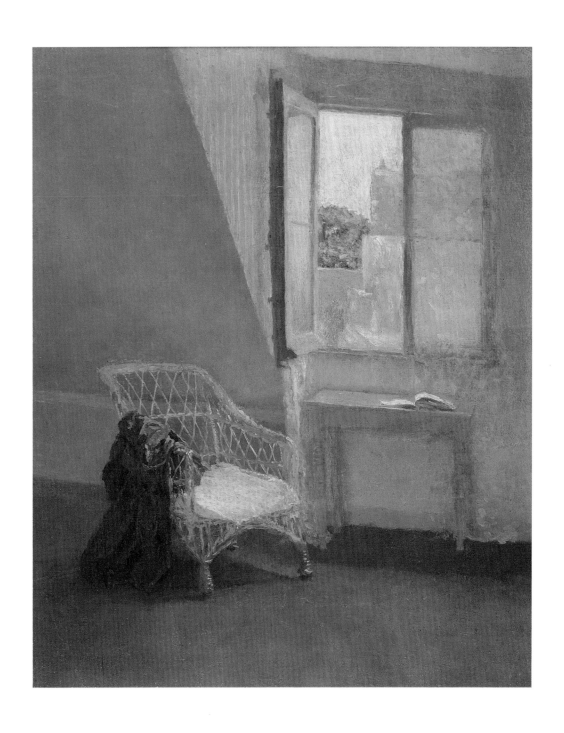

23. A corner of the artist's room in Paris (with book)
1907–09, oil on canvas over board. 12½ × 10 (32 × 25.5)
Private collection

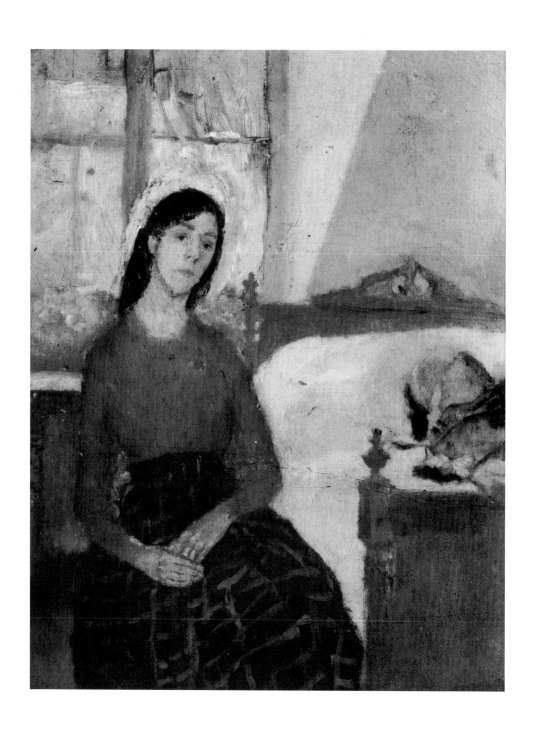

24. The artist in her room in Paris
1907–09, oil on canvas. 10¾ × 9 (27.5 × 23)
Sara John

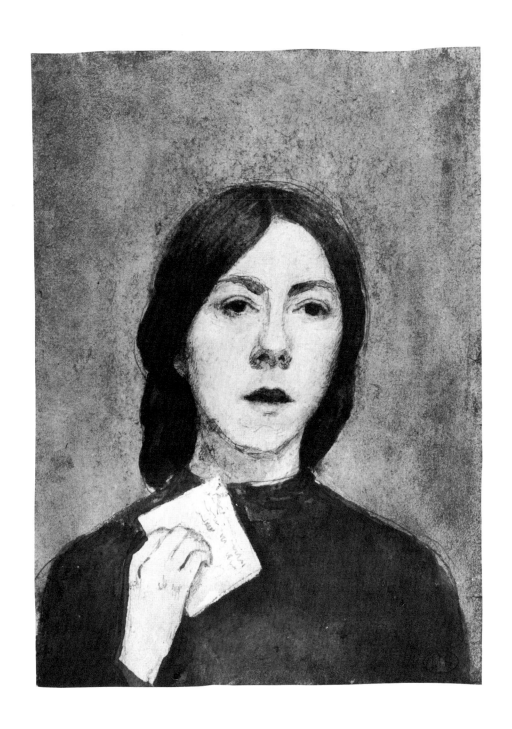

25. Self-portrait with a letter
1905–10, watercolour. 8¾ × 6¼ (22 × 16)
Musée Rodin, Paris

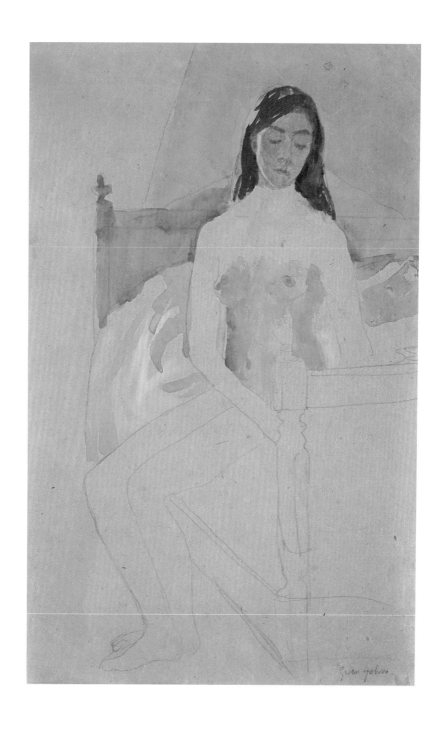

26. Self-portrait nude, sitting on a bed
1908–09, pencil and gouache. 10 × 6⅜ (25.5 × 16)
Private collection

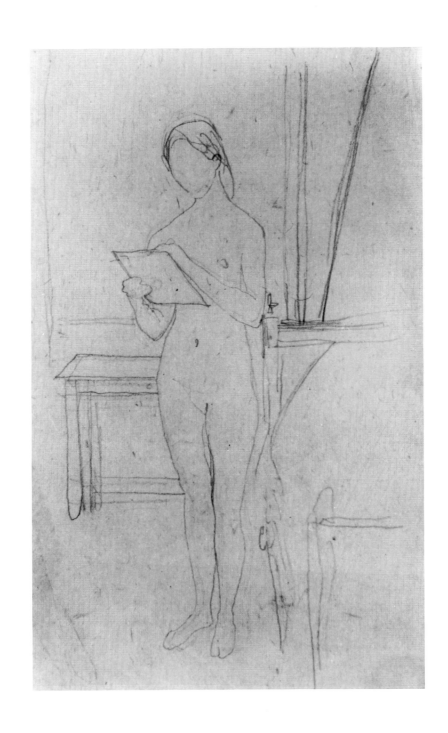

27. Self-portrait nude, sketching
1908–09, pencil. $9\frac{1}{4} \times 6\frac{1}{2}$ (23.5 × 16.5)
National Museum of Wales

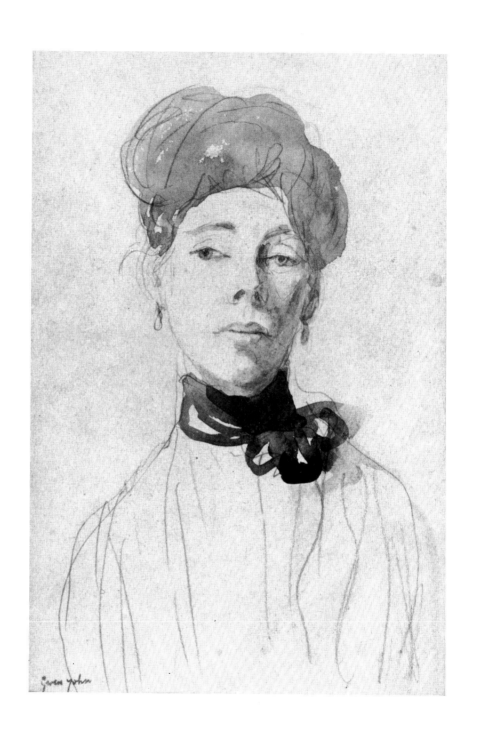

28. Portrait of a lady
1906–11, pencil and wash. $9\frac{1}{2} \times 6$ (24 × 15)
Swindon Museum and Art Gallery

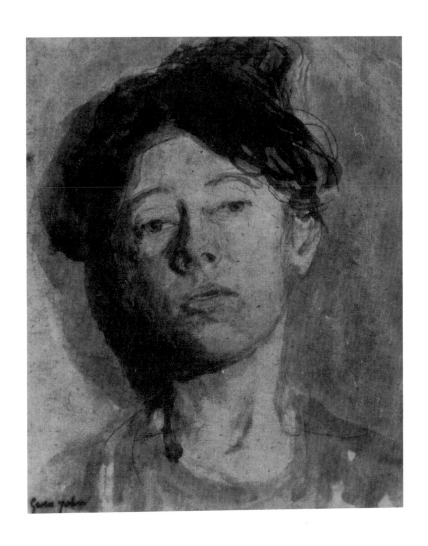

29. Portrait of a lady
1906–11, pencil and wash. Dimensions unknown
Whereabouts unknown

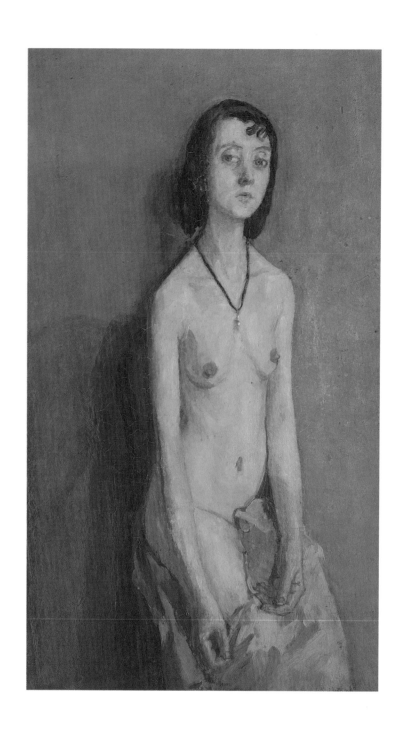

30. Nude girl

1909–11, oil on canvas. $17\frac{1}{2} \times 11$ (44.5 × 28)
Tate Gallery, London

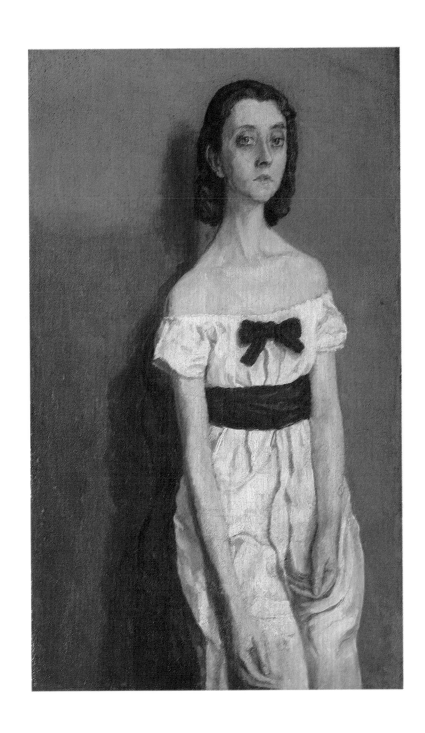

31. Girl with bare shoulders
1909–11, oil on canvas. $17\frac{1}{8} \times 10\frac{1}{4}$ (43.5 × 26)
Collection, The Museum of Modern Art, New York. A. Conger Goodyear Fund

32. Chloë Boughton-Leigh
1907–10, pencil and wash. 13 × 9 (33 × 23)
Private collection

33. Chloë Boughton-Leigh
1907–10, pencil and wash. $7\frac{3}{4} \times 5\frac{7}{8}$ (19.5 × 15)
Private collection

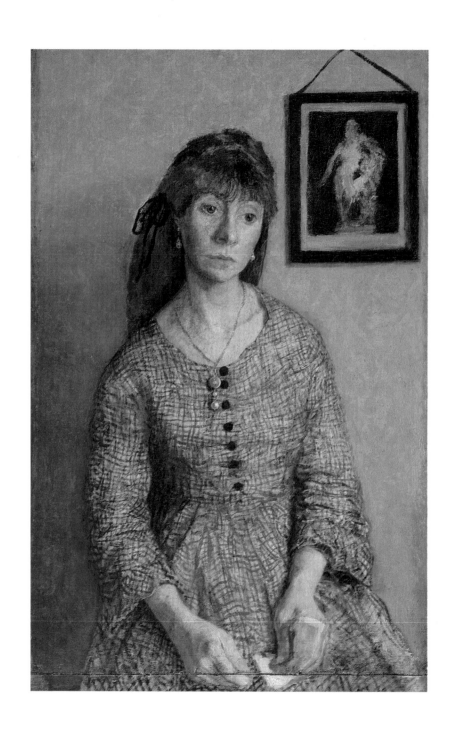

34. Chloë Boughton-Leigh (with loose hair)
1905–08, oil on canvas. 23 × 15 (58.5 × 38)
Tate Gallery, London

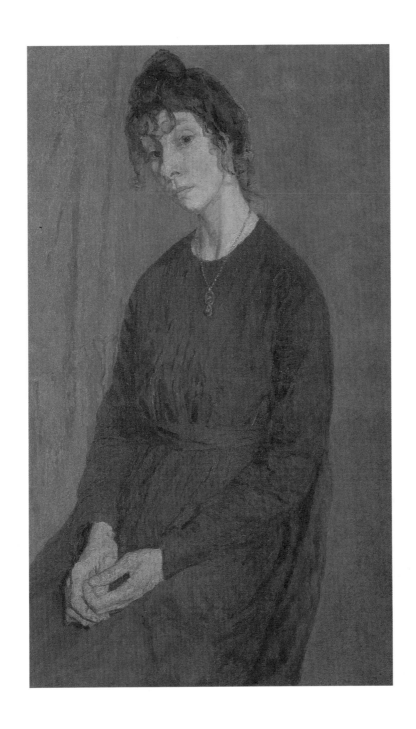

35. Chloë Boughton-Leigh (with her hair in a bun)
1910–14, oil on canvas. 23¾ × 14⅞ (60.5 × 38)
Leeds City Art Galleries

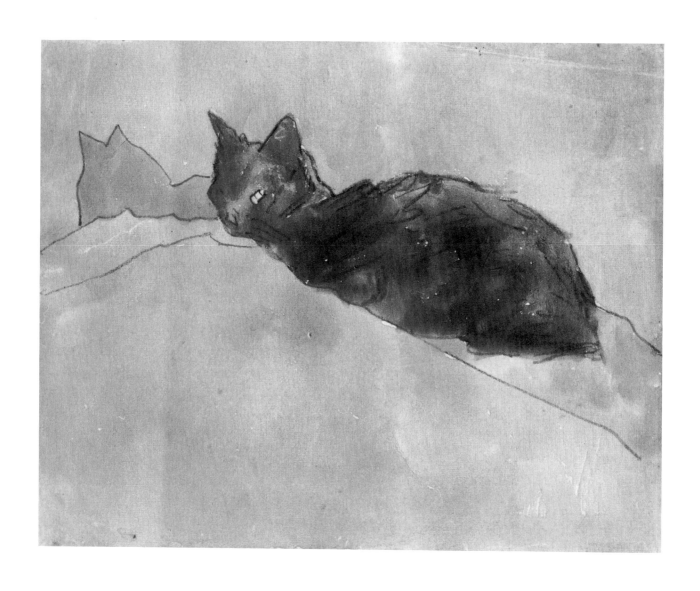

36. Black cat on blue against a pink background
1909–14, pencil and watercolour. 7 × 8¾ (17.5 × 22)
Ben John

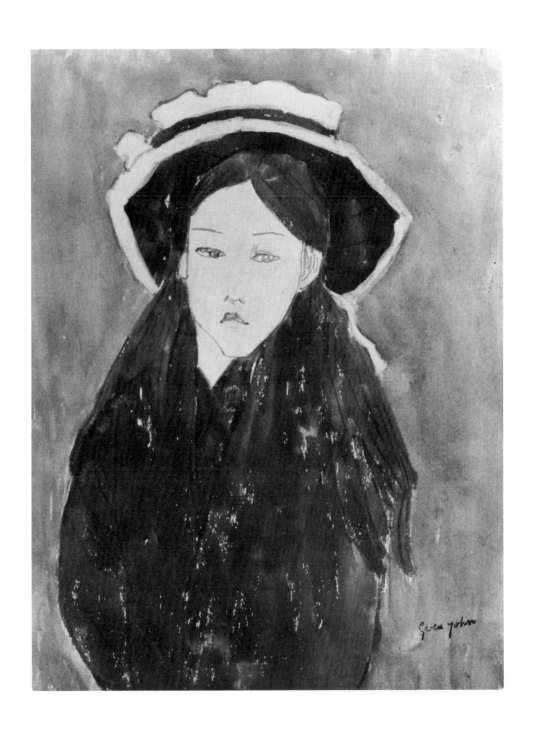

37. Little girl with a large hat
1909–14, pencil and gouache. $8\frac{1}{4} \times 6\frac{1}{2}$ (21 × 16.5)
Private collection

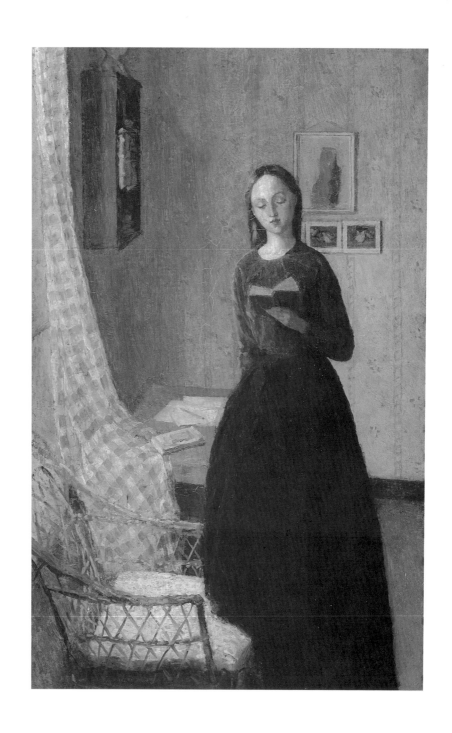

38. A lady reading

1910–11, oil on canvas. $15\frac{7}{8} \times 10$ (40.5 \times 25.5)
Tate Gallery, London

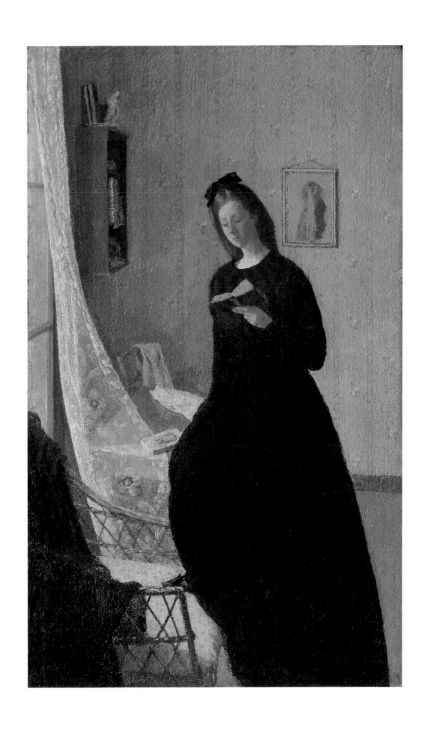

39. Girl reading at the window
1910–11, oil on canvas. 16 × 10 (40.5 × 25.5)
Collection, The Museum of Modern Art, New York. Mary Anderson Conroy Bequest
in memory of her mother, Julia Quinn Anderson

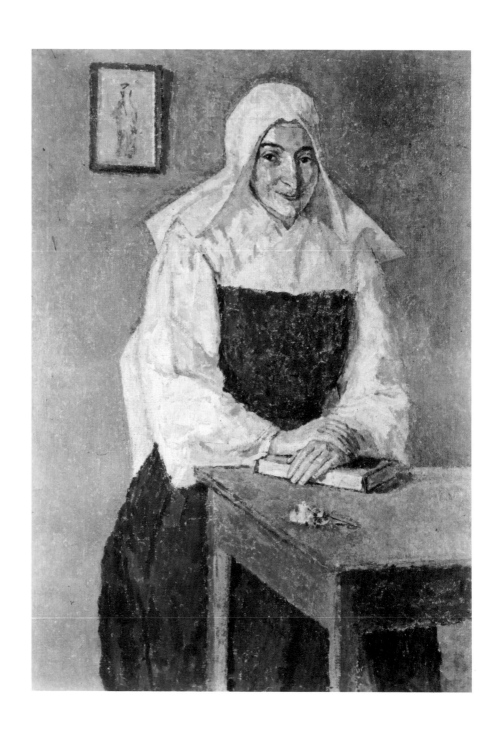

40. Mère Poussepin
1913–21, oil on canvas. 34¾ × 25¾ (88 × 65.5)
National Museum of Wales

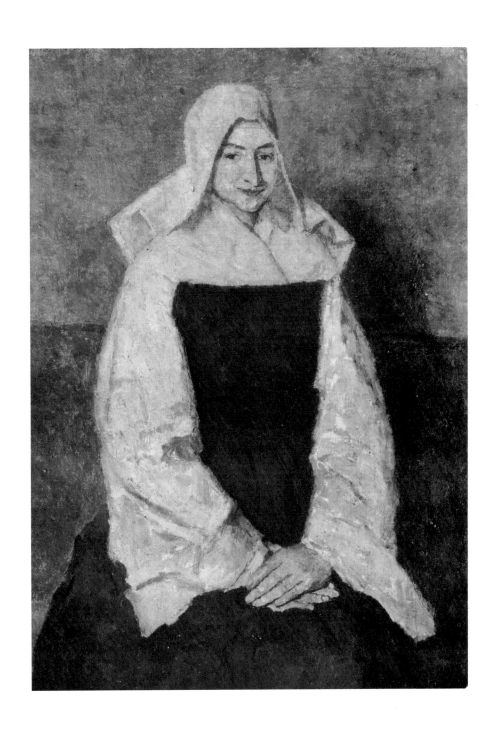

41. Mère Poussepin (hands in lap)
1913–21, oil on canvas. 24 × 17¾ (61 × 45)
The Barber Institute of Fine Art, the University of Birmingham

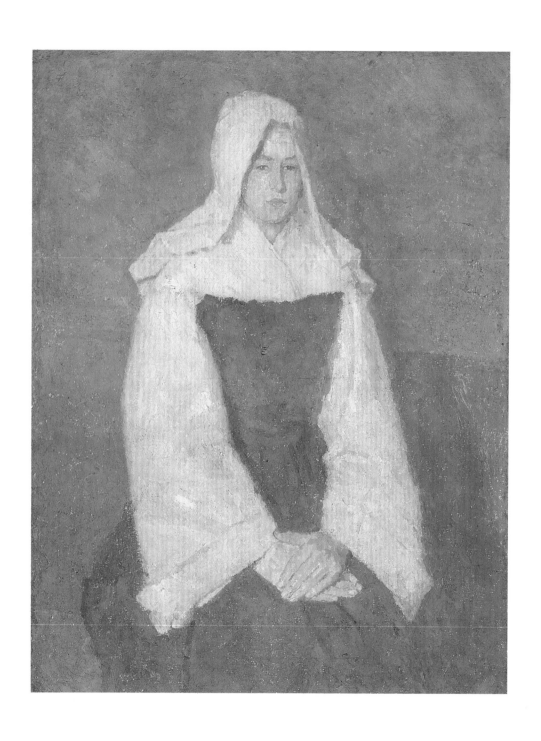

42. A young nun
1915–25, oil on canvas. $25\frac{1}{2} \times 19$ (65 × 48.5)
National Galleries of Scotland, Edinburgh

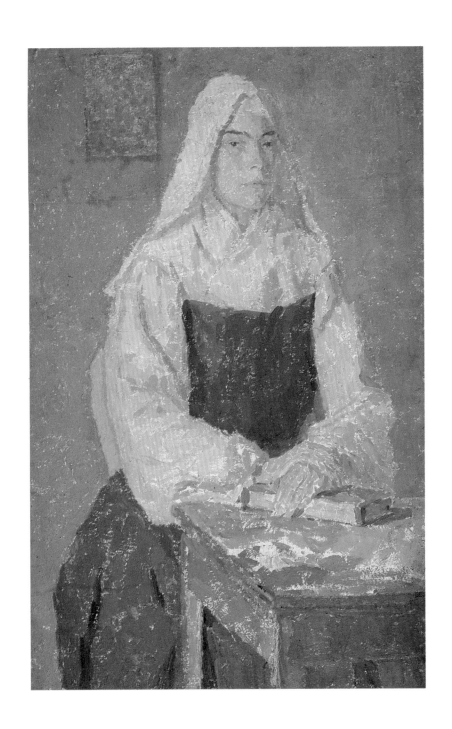

43. The nun
1915–25, oil on canvas. 27 × 17 (68.5 × 43)
Tate Gallery, London

44. Woman leaning on her hand
1911–18, pencil and watercolour with gouache. $6\frac{3}{8} \times 4\frac{7}{8}$ (16 × 12.5)
Private collection

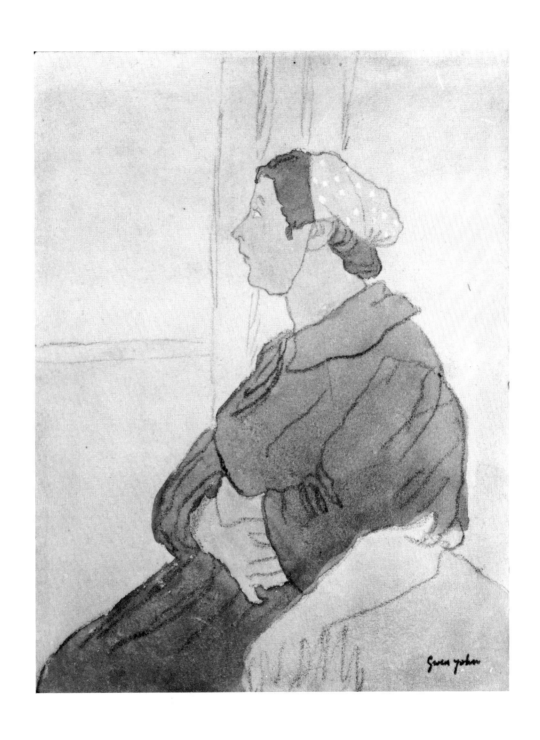

45. Peasant woman with her bundle
1911–18, pencil and wash. $8\frac{7}{8} \times 7$ (22.5 × 18)
Private collection

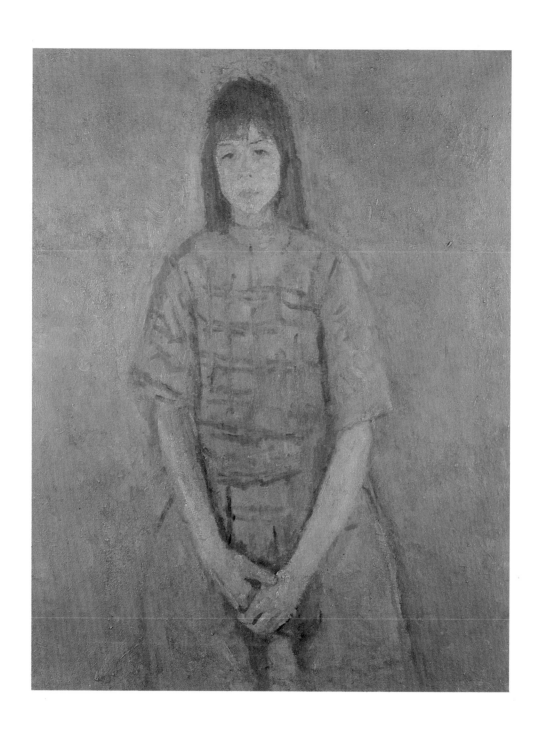

46. The little model
1915–23, oil on canvas. 21 × 18 (53.5 × 45.5)
Private collection

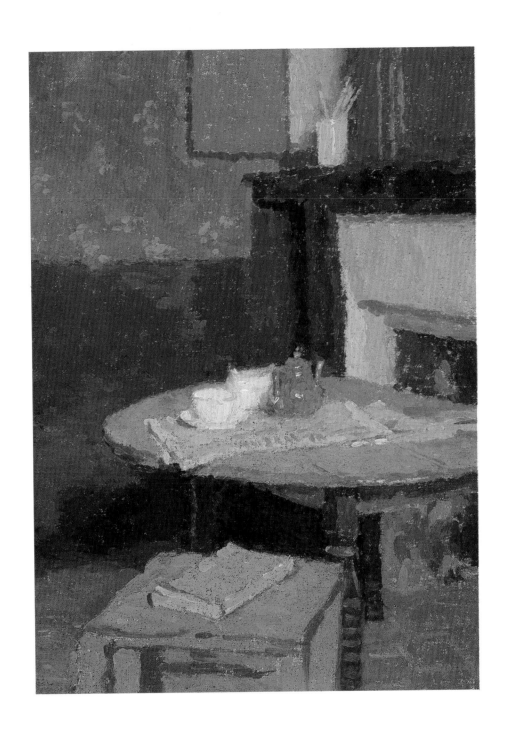

47. The teapot (Interior, *second version*)
c. 1915, oil on canvas. 13 × 9½ (33 × 24)
Yale University Art Gallery. The James W. and Mary C. Fosburgh collection

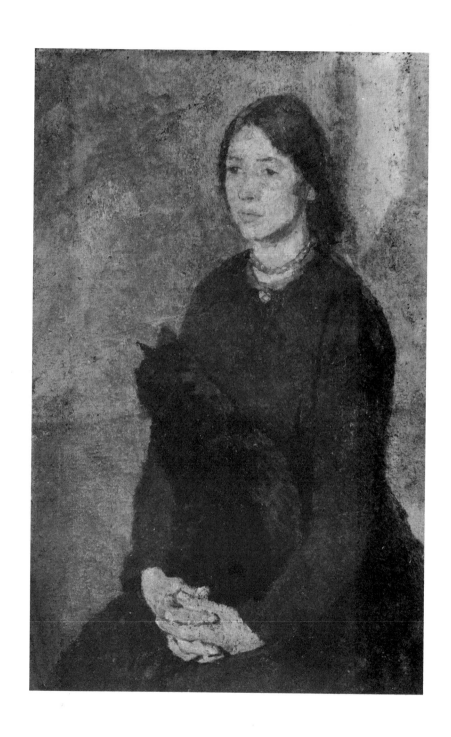

48. Young woman holding a black cat
1923–8, oil on canvas. 18 × 11⅝ (46 × 29.5)
Tate Gallery, London

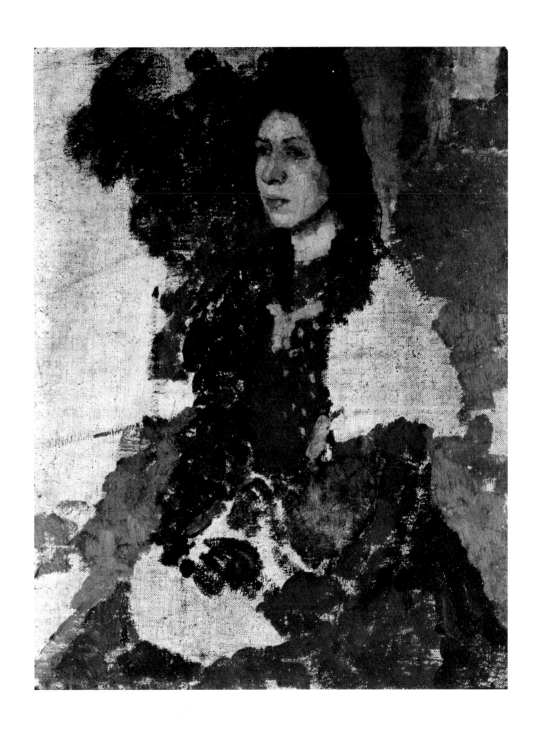

49. Girl holding a cat
1923–8, oil on canvas. $13\frac{3}{4} \times 10\frac{13}{16}$ (35×27.5)
From the collection of Mr and Mrs Paul Mellon, Upperville, Virginia

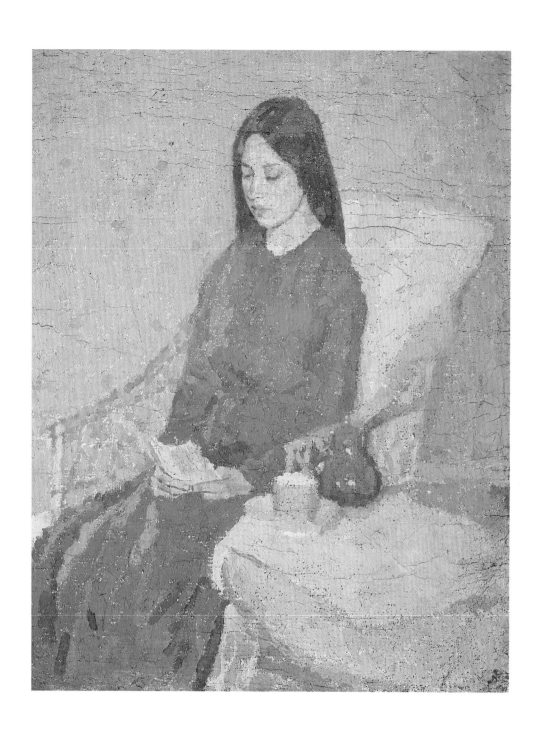

50. The convalescent

c. 1923, oil on canvas. 16⅛ × 13 (41 × 33)
Fitzwilliam Museum, Cambridge

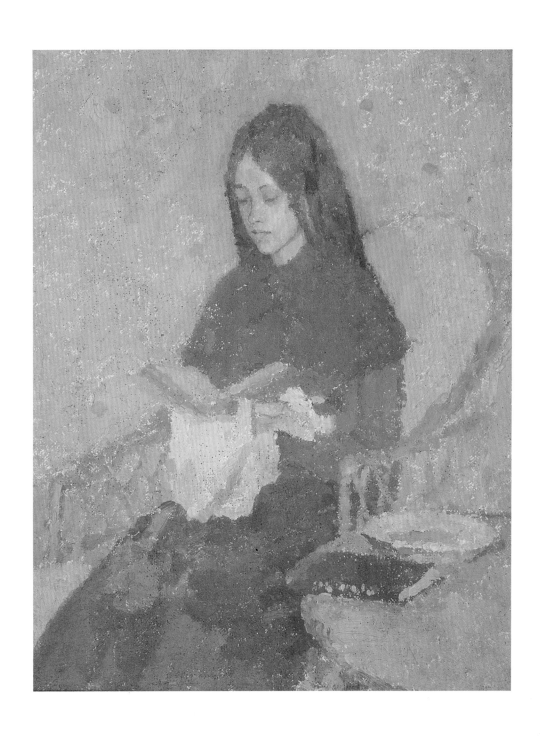

51. The precious book
1926, oil on canvas. 10 × 8½ (25.5 × 21.5)
Private collection

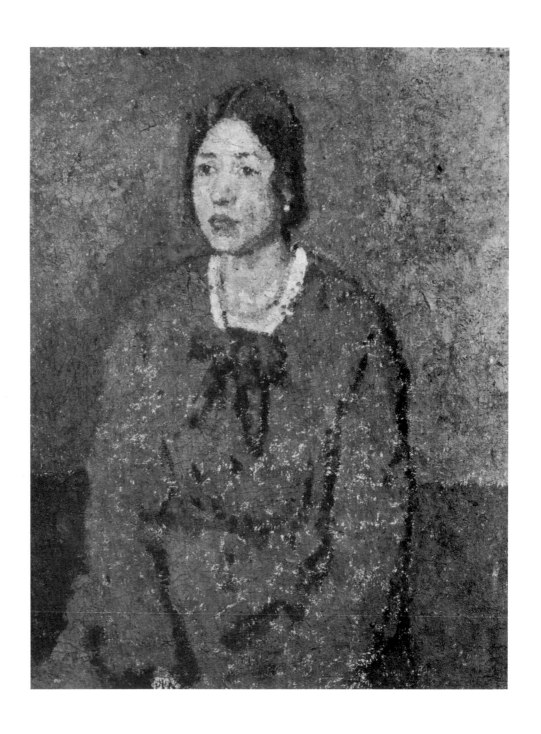

52. Girl with a blue bow
 c. 1926, oil on canvas. 16 × 12¾ (40.5 × 32.5)
 Welsh Arts Council

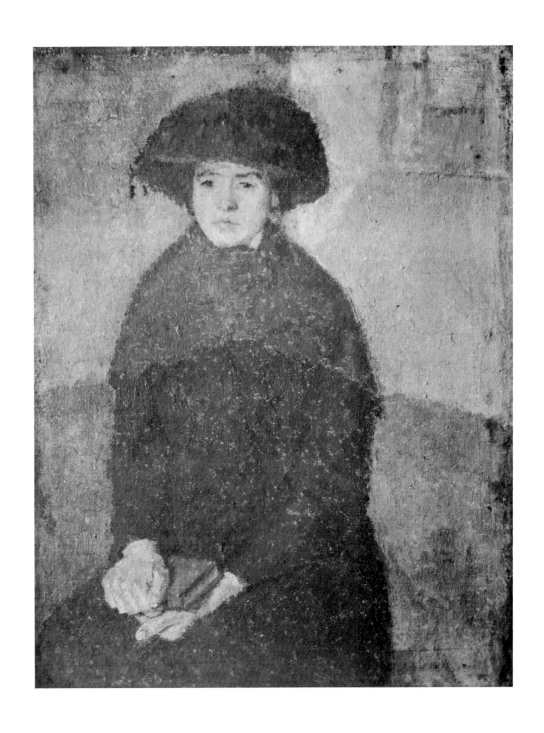

53. Girl in a hat with tassels
1921–6, oil on canvas. 18 × 14½ (45·5 × 37)
Private collection

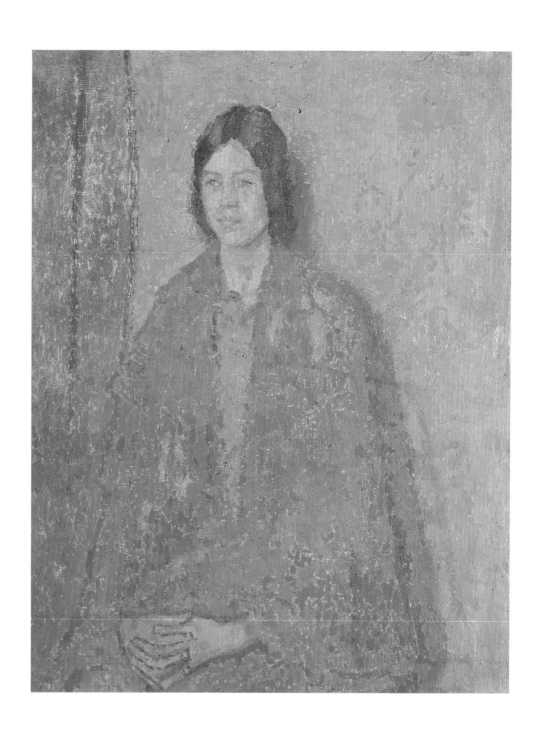

54. Young woman in a red shawl
1922–5, oil on canvas. 17¾ × 13¾ (45 × 35)
York City Art Gallery

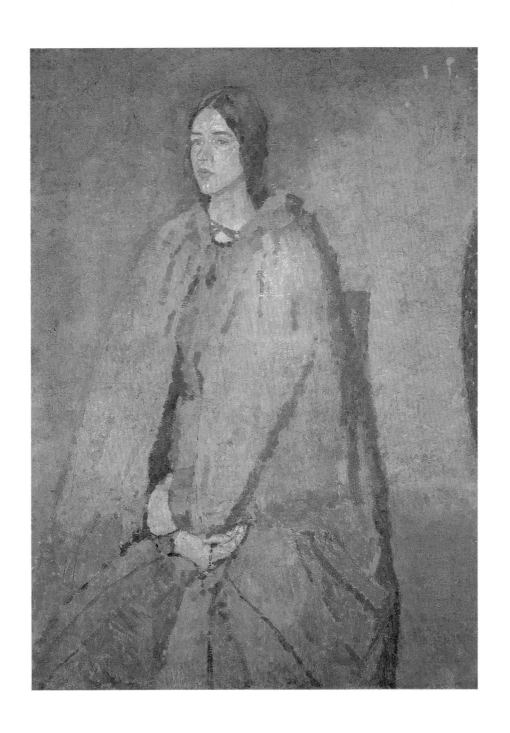

55. The pilgrim
1922–5, oil on canvas. 29 × 21 (73.5 × 53.5)
From the collection of Mr and Mrs Paul Mellon, Upperville, Virginia

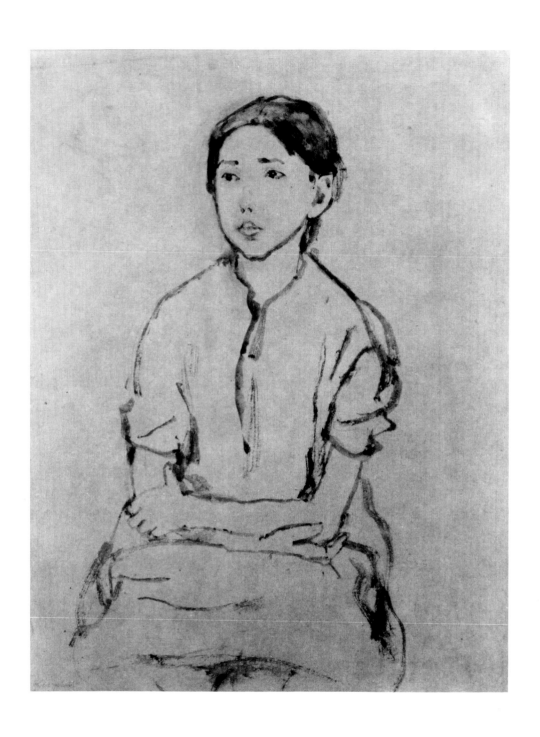

56. Girl with arms folded
1918–19, brush and ink. 12½ × 9½ (32 × 24)
Private collection

57. Little girl by lamplight
1918–19, charcoal. $9\frac{1}{8} \times 8\frac{5}{8}$ (23.5 × 22)
Private collection

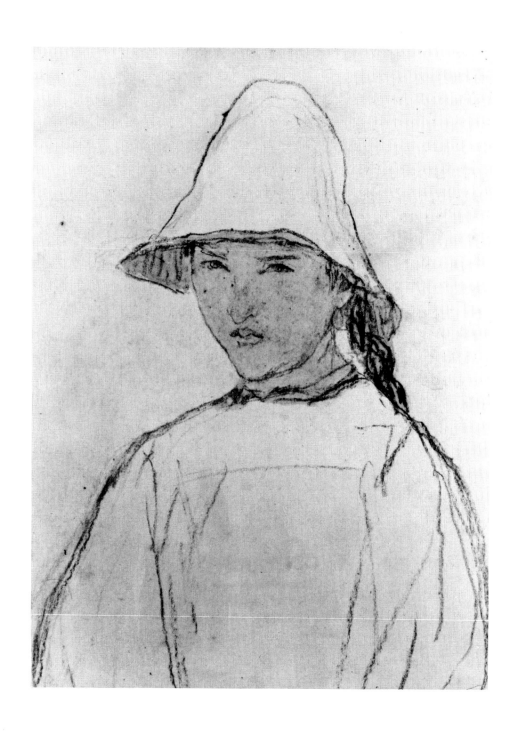

58. Girl in a sunhat (Odette Litalien)
1918–19, charcoal and wash. 12¾ × 9⅞ (32.5 × 25)
Ashmolean Museum, Oxford

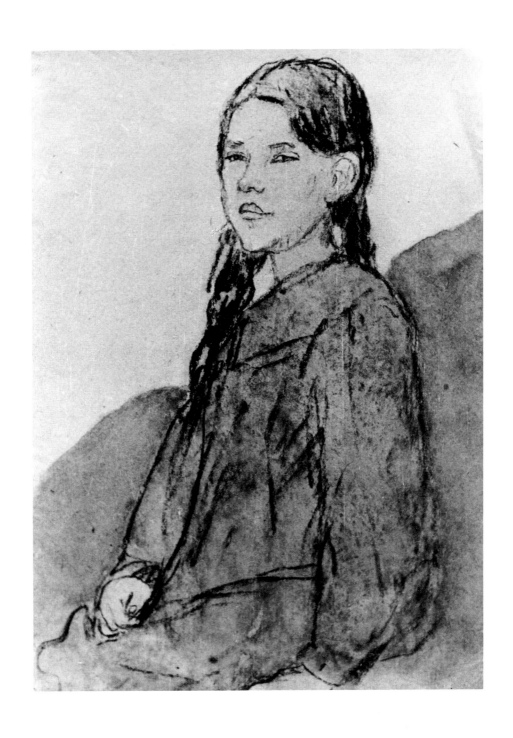

59. Girl on a clifftop (Marie Hamonet)
1915–17, charcoal and wash. 12½ × 9½ (31.5 × 24)
Private collection

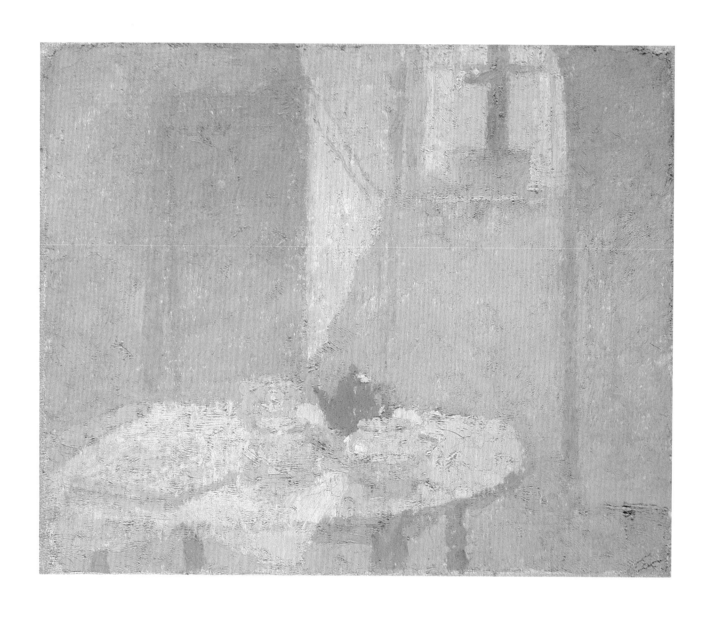

60. Interior (rue Terre Neuve)
1920–24, oil on canvas. $8\frac{5}{8} \times 10\frac{5}{8}$ (22 × 27)
Manchester City Art Galleries

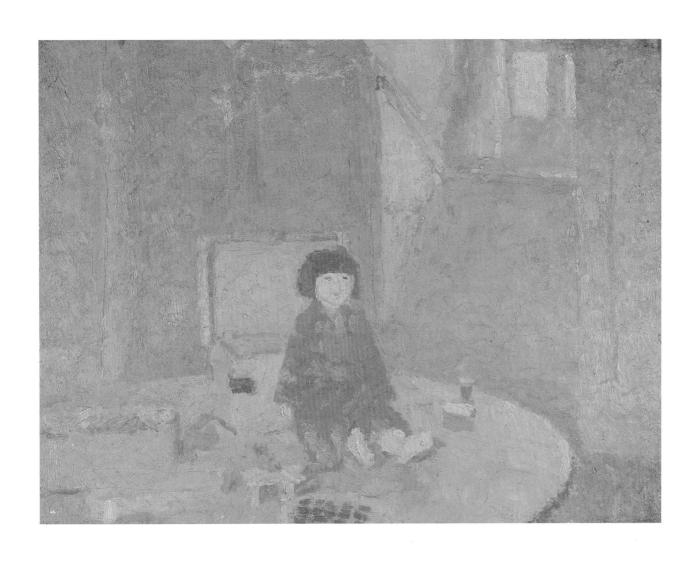

61. The Japanese doll
1924–9, oil on canvas. 12 × 16 (30.5 × 40.5)
Ben John

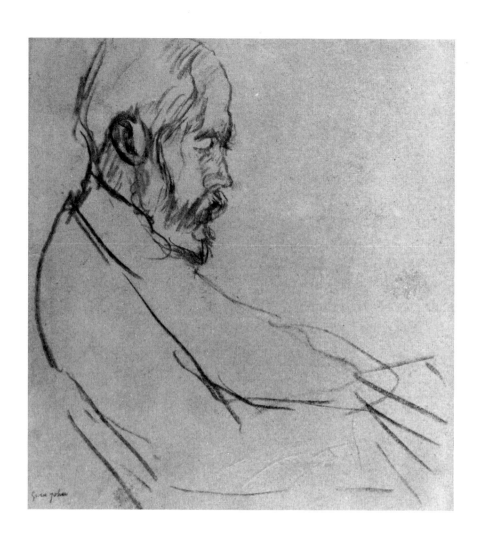

62. Profile study of Arthur Symons
1921, charcoal. $9\frac{5}{8} \times 8\frac{1}{2}$ (24.5 × 21.5)
By courtesy of the Board of Trustees of the Victoria and Albert Museum

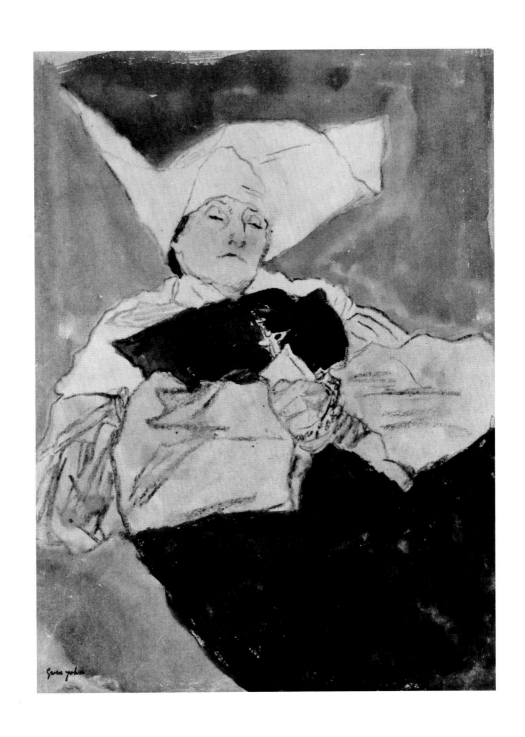

63. A nun on her deathbed
1916–26, charcoal and wash. 12⅜ × 9½ (31.5 × 24)
National Galleries of Scotland, Edinburgh

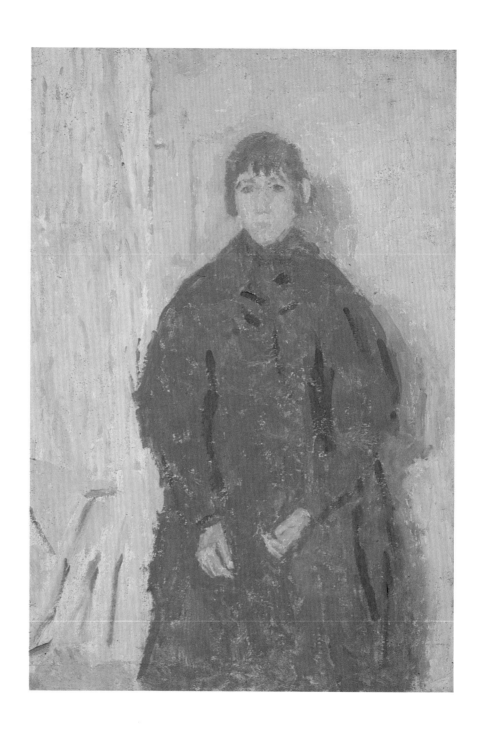

64. Woman in a mulberry dress

1920–23, oil on canvas laid on panel. 21¼ × 14¾ (54 × 37.5)
City of Southampton Gallery

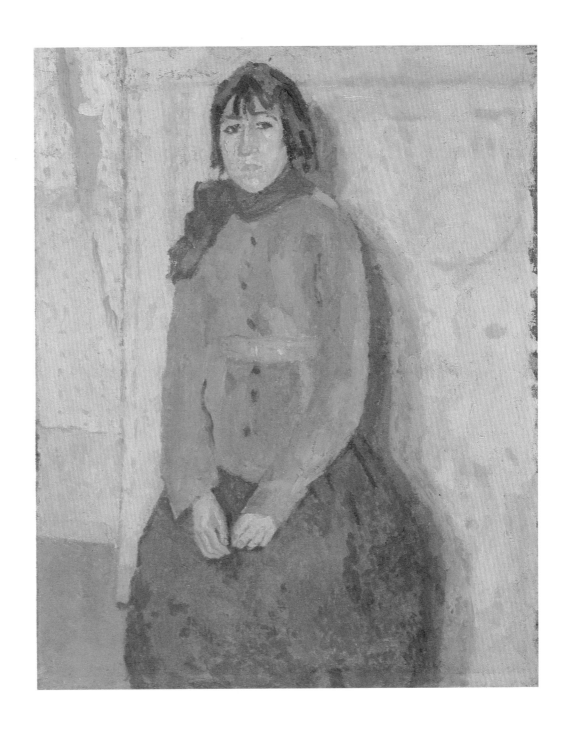

65. Girl with a blue scarf
1920–23, oil on canvas. 16¾ × 13 (42.5 × 33)
*Collection, The Museum of Modern Art, New York. Gift of Nelson A. Sears in
memory of Mrs Millicent A. Rogers*

66. A stout lady, and others, in church
1913–23, pencil and wash. 6⅜ × 5 (16 × 12.5)
National Museum of Wales

67. A nun in church
1913–23, pencil and wash. 6⅜ × 5 (16 × 12.5)
National Museum of Wales

68. Souvenir du dimanche des Rameaux
1927–32, pencil and wash. $5\frac{5}{8} \times 4\frac{3}{8}$ (14.2 × 11)
National Museum of Wales

69. Girl carrying a palm frond
1927–32, charcoal and gouache. $7\frac{3}{4} \times 7\frac{3}{4}$ (20 × 20)
National Museum of Wales

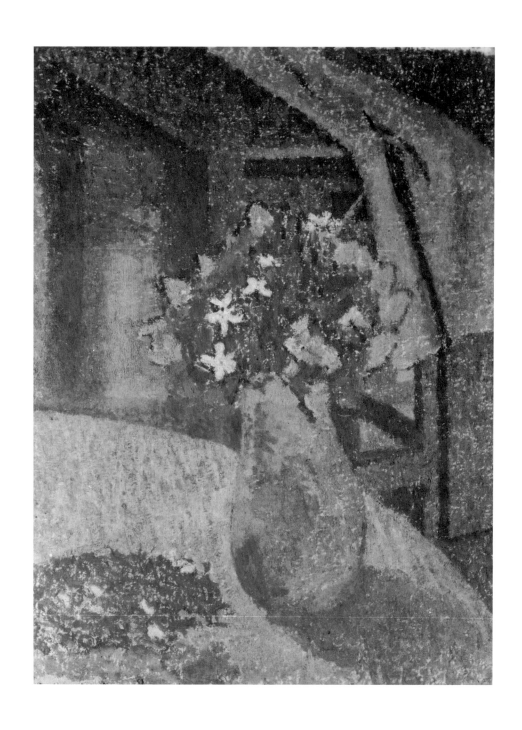

70. Still life with a vase of flowers
1924–9, oil on canvas. 15½ × 12½ (39.5 × 32)
National Library of Wales

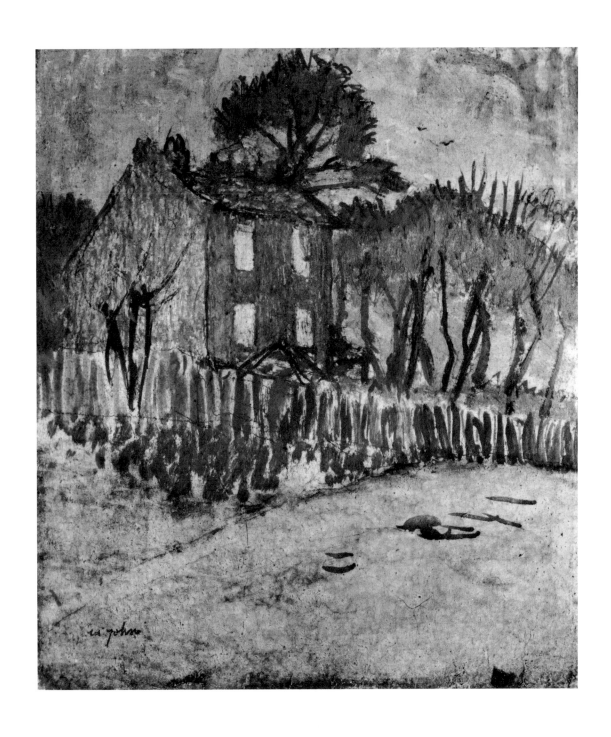

71. Red house at twilight
 c. 1932, gouache. 7 × 6½ (18 × 16.5)
 Private collection

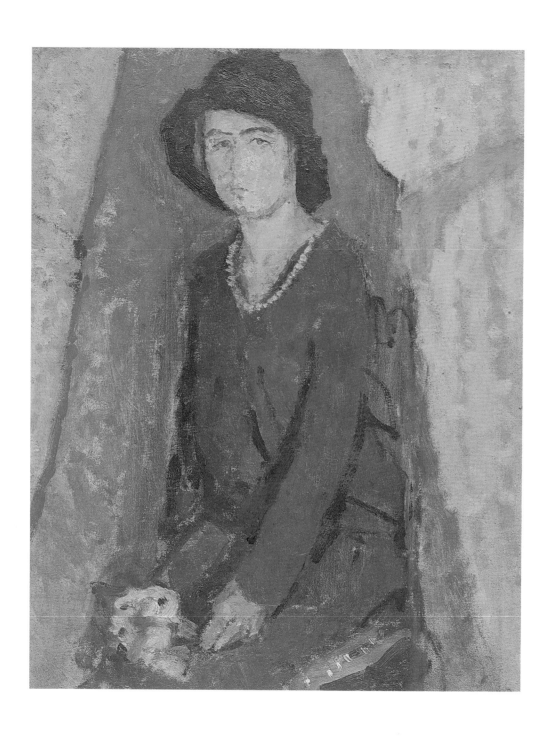

72. Bridget Bishop
1929, oil on canvas. 16 × 12¾ (40.5 × 32.5)
Anthony d'Offay Gallery

Notes to Plates

Frontispiece. **Self-portrait**

This drawing was first exhibited in the 1946 Memorial Exhibition in London (no. 57) where it appeared under the title *Self-portrait of the artist at the age of about twenty years*. The style of the drawing suggests that Gwen John's age was nearer thirty than twenty when it was made.

In manner as well as in appearance Gwen John seems to have given the impression of being younger than her years. A letter to Rodin written in 1905–06 contains an account of one occasion when she was reduced to tears by the spiteful comments of a certain Miss O'Donnel for whom she posed and who upbraided her for her ingenuous air. 'She told me,' Gwen John wrote, 'that I was much too young for my age, that I had the mind of a child of fourteen – and that I would be more *charming* if I were more grown-up and a great many other wounding things of that kind.'

1. **Winifred John**

This portrait of her sister Winifred is one of the very few paintings to have survived from Gwen John's student years. It is also one of her very few pictures done in thick paint vigorously applied with a large brush. The painting is a remarkable likeness; and already the likeness grows out of an understanding of the form and solidity of the head in a manner entirely characteristic of Gwen John. Winifred Maude (born 3 November 1879) was the youngest of the John children and with her Gwen John had a close and loving relationship. For a time she studied music in London and briefly shared rooms with Gwen and Augustus in Fitzroy Street in the winter of 1897–8.

From the summer of 1903 she made her home in the USA, earning her living as a violinist and teacher of music. She returned briefly to Europe on at least one occasion (in 1907) and in 1915 she married in the United States and settled in California. She died in Martinez on 12 April 1967.

The picture belonged to Gwen John's father and for many years it hung in his house in Tenby. Following his death in 1938 his housekeeper, Miss Elizabeth Davies, was given the picture when the household effects were disposed of by Augustus John. In 1971 it was acquired from Miss Davies's heirs by Tenby Museum.

2. **Landscape at Tenby, with figures**

From the age of eight Gwen John lived with her family in the town of Tenby on the coast of Pembrokeshire. Her life became centred in London after her arrival there in 1895 to study at the Slade School of Fine Art. Nevertheless, several times a year she returned, apparently less by choice than by necessity, to spend the vacations at her father's house.

This painting shows Tenby harbour from the North Sands. The view is almost unchanged today. For all its awkwardness, the picture has so much subtle and knowledgeable drawing that it seems certain to have been painted some time after Gwen John's arrival at the Slade; and the figure of the little girl is already seen with that tender intensity which is the hallmark of her mature work. Tentative, exploratory, unresolved, the picture has about it something of the dream-like quality of a memory painting.

For many years, this canvas lay in a cupboard at

Fryern Court, the home of Augustus and Dorelia John. On a visit there in 1967, I was shown it by Dorelia who produced it with some reluctance and who, until then, had considered it too unimportant to mention. It was subsequently exhibited for the first time in the Arts Council's Gwen John Retrospective Exhibition, 1968 (no. 1).

3. A group of students

By the autumn of 1897 Winifred John had come to London to study music and soon afterwards was sharing rooms with Augustus and Gwen John and Grace Westry on the first floor of 21 Fitzroy Street. Though probably drawn between this time and Gwen John's departure from the Slade in late June 1898, this picture seems not to be set in their Fitzroy Street rooms[1]. The fireplace suggests a humbler location, perhaps the basement room in Howland Street where she is known to have lived for a time, possibly in 1898.

The figure of a girl on the left is Rosa Waugh, a fellow student at the Slade. Augustus John leans on the mantelpiece. Winifred John sits at a table which is covered by a curtain dragged over from the window and held in place by a dressing-table mirror for compositional effect. (A similar compositional device is used in later pictures – cf. Pls 38 and 39). Another Slade student, Michel Salaman, a close friend of both Gwen and Augustus, is intently drawing a single marguerite which appears to be returning his studious gaze. The light-hearted vein is continued in the scene through the window where a vaguely romanticised couple are glimpsed walking in the garden. According to Michel Salaman's sister Dorothy, Gwen John described the couple in the garden as 'myself and an admirer' and the top-hatted figure was thought to be a caricature of Ambrose McEvoy.

This portrait group is unusual in Gwen John's surviving oeuvre in combining a statement of directly observed fact with an attempt at an art-school 'composition', the demands of which may perhaps account for

the uncharacteristic error in drawing in the figure of Rosa Waugh. Gwen John, in common with all Slade students at this time, would certainly have had to produce numerous compositional studies, and indeed she is known to have excelled in this field[2]. The picture is close in style to some of the illustrative work produced by her contemporaries, notably Rosa Waugh's sister Edna (Clarke Hall). Edna Clarke Hall was the original owner of this picture. It was purchased from her by Dorothy Samuel (*née* Salaman) after whose death it was acquired by its present owner.

4. Winifred John in a large hat

This drawing is among the earliest by Gwen John to have been preserved. If the sitter (b. 3 November 1879) were the fourteen- or fifteen-year-old she appears to be, the drawing would have been made not later than 1895, when Gwen John herself had barely arrived at the Slade. The confident and mature draughtsmanship suggest a later date. It is possible that Winifred's youthful appearance is due to a hairstyle and costume contrived for the purpose of 'dressing up' for the pose (Gwen John is known to have taken pains over the costume and pose of her models). Even so, the sitter's age seems to rule out a date later than 1897, though Gwen John would have been only a second-year student at that time.

I first saw this drawing in April 1953 at Fryern Court, the home of Augustus John, and recall his obvious pleasure in examining it, and his comment that it was a most remarkable likeness.

5. The artist's sister Winifred

Ethel Hatch, a contemporary of Gwen John's at the Slade, remembered seeing a painting by her in 1899 which showed a 'young woman fastening her glove in the same pose as a painting by Whistler.'[3] Miss Hatch recalled that the picture appeared at the New English Art Club in the spring of 1899 – the first oil painting by Gwen John to be shown there, she said. No picture by Gwen John is listed in the catalogue for that exhibition but a portrait with the title *Miss Winifred John* was

1. 21 Fitzroy Street no longer exists but the appearance and the elegant proportions of the first floor have been clearly recorded (see *A Window on a London Street* painted in 1901 by William Orpen, reproduced in Bruce Arnold, *William Orpen, Mirror to an Age*, London 1981, p. 100).

2. In the year 1897–8 she was awarded the Melvill Nettleship Prize for figure composition.

3. Letter to Mary Taubman 22 February 1968.

shown there in the spring of 1901 (no. 102). That picture seems likely to have been this one – the only portrait of Winifred by Gwen John to be listed in the New English Art Club catalogues. Stylistically, however, the picture seems to pre-date the two extremely mature and confident portraits shown at the New English Art Club in 1900 (see Pls 9 and 10). The painting was purchased by Gwen John's friend and Slade contemporary Louise Salaman. Several members of the Salaman family lent pictures to Gwen John's Exhibition at the New Chenil Galleries, London, in 1926, and it is assumed that the picture entitled *Winifred* which appeared there (no. 43) was this one.

6. Half-profile of Winifred John

Difficulties arise over the dating of Gwen John's drawings of her sister Winifred. The date appropriate to the sitter's age seems often to conflict with that suggested by the style of the drawing. Perhaps it can be said that accepted conventions of dress were of little importance in the bohemian circles the John girls frequented after their move to London. Winifred John seems to have worn her hair long much later than was the normal practice (cf. Pl. 3). Though in this drawing she could be thought to be about seventeen its style suggests that she is a good deal older. It is possible that the drawing was done as late as 1907 when Winifred made a short visit to Gwen in Paris.

Another, very similar, drawing of Winifred John was included in the Arts Council's 1968 Retrospective exhibition (no. 51).

7. Young woman sewing, sitting on the ground

The sitter is Winifred John. She appears to be holding, rather than sewing, a fringed scarf or kerchief. There are at least two other almost identical versions of this drawing (listed Arts Council Retrospective 1968, no. 57).

8. Grace Westry with a violin

During her first year at the Slade Gwen John became friendly with Grace Westry and together they spent part of the summer vacation of 1896 at the Johns's home in Tenby. This picture belongs to a later time. It could have been painted during the period from late 1897 to 1898 when Grace Westry shared a flat at 21 Fitzroy Street with Gwen, Augustus and Winifred John, or even a year later, following Gwen John's brief period of study in Paris at the Académie Carmen under Whistler. The picture lacks the verve and fluency of Gwen John's drawings of the later nineties. But the subtle and intense observation and the delicate handling of paint are entirely characteristic of her, as are several items of the subject-matter – the wicker-work of the waste paper basket, the rectangles of background picture and foreground book (or in this case, music) set at an angle on a low stool, are some of the ingredients of later paintings (cf. Pl. 47). During the 1890s, and indeed for many years after, the subject of the intimate interior with one or more figures (often friends of the artist) was much favoured by painters with Slade and New English Art Club connections. It was also used by Whistler and, in France, by the Nabis. But this version of it by Gwen John seems to look back into the nineteenth century and has an intensely British flavour much closer to Orchardson than to Vuillard.

The painting was for many years in the possession of Augustus and Dorelia John. When, during a rare visit to Fryern Court in the late 1920s Gwen John saw it there, she expressed astonishment that they should have preserved 'that old thing' and requested them to throw it out forthwith.

9. Mrs Atkinson

This picture, one of Gwen John's first completely assured and masterly paintings in the medium of oil, has a maturity which suggests a date later than both her time at the Slade and the time of her first sojourn in Paris in 1898–99. It was shown in the New English Art Club winter exhibition, November–December 1900 (no. 38); and it was acquired at about that time by Gwen John's friend and fellow student Louise Salaman, and from her by her brother Michel Salaman. He described it to me as a portrait of Gwen John's landlady. It is difficult to keep track of Gwen John's lodgings during the years she spent in London. From late 1899 and throughout 1900 she lived intermittently at 122 Gower Street. The name of Atkinson seems not to be associated with that address or with any of Gwen John's other known addresses before 1900, though *Kelly's Post Office Directory* for 1899 lists a Mrs

Emily Adelaide Atkinson who kept a boarding house in Gower Street at no. 56. In 1900 a private hotel is listed close by, at 183 Euston Road. Its proprietor has the name Jacob Atkinson. It is just possible that the picture was painted there for Gwen John did live in the Euston Road at some point after leaving the Slade.

What is known for certain is that Gwen and Augustus John spent a good deal of time together in 1899 and 1900. For a time they shared lodgings in Fitzroy Street; they went on holiday together – in the spring of 1900 to Swanage, in late summer to France. Augustus John's first commission, *Portrait of an old lady*, begun in 1899, is the only painting of his to show Gwen John's strong influence; and it is tempting to suppose a reciprocal influence on her choice of subject matter in *Mrs Atkinson* – one of her rare paintings of old age.[4] A portrait drawing (Fig. 3) done at about this time by Augustus shows Gwen seated, like Mrs Atkinson, beside a fireplace. On the mantelpiece there is a human skull. The skull on the mantelpiece in the portrait of Mrs Atkinson appears to be that of a sheep. It would be wrong to suppose that the skulls have a consciously symbolic significance.

Mrs Atkinson was borrowed from Michel Salaman for inclusion in Gwen John's exhibition at the New Chenil Galleries in London in 1926 (no. 35) where Anthony Bertram (*Saturday Review*, 5 June 1926) saw it as the 'one great picture' of the exhibition. The picture is also known as *Old woman wearing a bonnet*.

10. Self-portrait

Gwen John's hairstyle and costume in this portrait link it with drawings made of her by Augustus in the late 1890s (Fig. 3); and the costume itself indicates a similar date. The fashion for gigot sleeves was at its height in the middle of the decade 1890-1900 but after the turn of the century they began to go out of style. While Gwen John was no slavish follower of fashion, she cared enough about clothes to make it seem unlikely that she would

4. There is a not dissimilar drawing of an old lady, dating from about this time, by Ambrose McEvoy (until recently in the possession of his family). Their Slade contemporary William Orpen included a picture entitled *An old lady* (no. 6) in his first exhibition, held at the Carfax Gallery in 1901.

have portrayed herself in so modish a garment when it was noticeably out of date. The picture is strikingly confident and mature in comparison with her known work up to this time, and it was probably painted some time after her return from the Académie Carmen in Paris in the spring of 1899. A picture entitled *Portrait of the artist* by Gwen John was shown in spring 1900 (no. 104) at the New English Art Club – the first picture by her to be hung there. It seems likely to have been this *Self-portrait*. The picture's spirit of bravura sets it apart from other paintings by Gwen John and the flickering Titian-like brushwork suggests that she had been following Henry Tonks's frequent exhortations to his Slade students that they should study at the National Gallery. The pose and composition of the picture are also reminiscent of one of the Gallery's recent acquisitions of the time, the *Doña Isabel de Porcel* by Goya (purchased in 1896). Allowing for the adjustments a self-portrait would demand – the raised fore-arm and the head turned towards the spectator – the pose of the figure, set against its dark background, is very similar to the Goya picture. A new interest in Spanish painting had been growing among Slade students since the publication in 1895 of R. A. M. Stevenson's *Velasquez*, and in 1900 Will Rothenstein, who was a friend of both Gwen and Augustus John, published his book on Goya. In the winter of 1899–1900 Goya was certainly in Gwen John's mind. William Orpen, who had just moved in at 21 Fitzroy Street, wrote to Albert Rutherston describing a fancy-dress party he held there that winter. Gwen John came to it dressed as a Spanish lady from a painting by Goya.

This *Self-portrait* belonged to Augustus John until his death in 1961.

11. Self-portrait

In the spring of 1902 the teachers at the Slade under Professor Fred Brown organised an exhibition to which former students were invited to contribute. This *Self-portrait* was the picture submitted by Gwen John. It was immediately purchased by Professor Brown. Writing to Michel Salaman in late April or early May of that year Augustus John reported: 'Gwen has done a wonderful masterpiece which Brown has bought already.' The words imply a new and recently-completed work and one not yet known to Salaman; and since he was, at this

period, one of Gwen John's most intimate friends and had visited her in January that year at Augustus and Ida John's home in Liverpool, it seems reasonable to assume that the painting was done between January and April. During much of that time Gwen John was part of Augustus's household in Liverpool,[5] acting as companion and helper to Ida John whose first child had been born on 6 January.[6]

It is astonishing that a picture of this quality should have been produced under these conditions – doubly so since the technique employed (the picture is slowly built up with delicate layers and glazes of colour over a monochrome base) is one which calls for the utmost restraint, discipline and concentration. This technique, or variants of it, was used then and later by other Slade painters, notably William Orpen[7], but Gwen John is reputed to have learned it from Ambrose McEvoy who was one of her close friends and who for many years, and particularly between 1898 and 1902, had been engaged in an intensive study of the methods of the old masters.

The picture remained in Professor Brown's possession till his death and he included it in the background of a *Self-portrait* painted in 1920 (now in the Ferens Art Gallery, Hull). He bequeathed it to his niece from whom it was acquired by the Tate Gallery in 1942.

After its original appearance in the Slade show the picture was not exhibited again until 1925 when it was shown in the Special Retrospective Exhibition (1886–1924) of the New English Art Club (no. 65). For that reason it has been previously supposed that this *Self-portrait* must be the *Portrait of the artist* which had been shown on an earlier occasion at the New English Art Club (spring 1900). See note to Pl. 10 above.

The picture is signed with the initials G M J, the only one of Gwen John's works (apart from the possibly attri-

5. 41 Colville Terrace, Bayswater, which appears as Gwen John's address in the New English Art Club catalogue of spring 1902, was in fact the address of the McEvoy family. She is known to have lived there for a time and may also have used it as a forwarding address.
6. In a studio photograph (Fig. 2) of Ida and Augustus with their baby, Gwen John appears wearing the black neckband and the cameo brooch of the *Self-portrait*.
7. Bruce Arnold, *William Orpen, Mirror to an Age*, London 1981, pp. 170–1.

butable *Shepherd with a flock of sheep*) to bear a signature (see p. 15).

12. Dorelia with bows in her hair

Dorothy McNeill (known to the John circle as Dorelia – and by the John family as Dodo) became friendly with Gwen John in London in 1902, and it was at about this time too that Augustus (who was now married to Ida Nettleship) met and fell in love with her. Early in August 1903 Gwen and Dorelia left London for Boulogne with the intention of walking to Rome, earning their living as they went by singing and by drawing portraits. In October the journey was abandoned at Toulouse and there they spent the winter, returning to Paris in the spring of 1904. Dorelia eventually went back to England late that summer. For a time she lived with Augustus and his wife Ida in a *ménage à trois*. Later, following Ida's death in 1907, she took over the role of wife, and remained with Augustus until he died in 1961. She survived him by almost eight years, and died at the age of eighty-seven in 1969.

This drawing and other portraits of Dorelia illustrated (see Pls 13, 14, 15, 16) date from the period 1903–04. The preferred medium for the portrait drawings of Dorelia is either red chalk or charcoal, with sometimes a broad outline under-drawing in pencil.

13. Dorelia by lamplight at Toulouse

'Our adventures are not now of such a thrilling nature as we live in a town and have a room to sleep in like any bourgeoise,' Gwen John wrote from Toulouse to her friend Ursula Tyrwhitt in the autumn of 1903. During the five or six months they spent there she painted this portrait of Dorelia, and at least two others (Pls 14 and 15). She is known to have been working on five pictures throughout that winter but whether all five were portraits has yet to be established. An unfinished (and now much restored) portrait of Dorelia (private collection) seated and wearing a black dress with a coral necklace and a white shawl remained in Gwen John's studio at her death. It could date from this time.

For *Dorelia by lamplight at Toulouse* and its two companion portraits Gwen John employed the technique she had already perfected in the *Self-portrait* of 1902 (Pl. 11), working with layers of paint over a base of

raw and burnt umber, colours favoured for under-painting because of their fast-drying properties. Because of the drying-out time necessary between applications of paint, the process is a prolonged one, and in the letter to Ursula Tyrwhitt quoted above, Gwen John hints at the difficulties involved. 'I have been slaving at my picture & now it will not be done for the N[ew] E[nglish] . . . I have not done much besides.' There was the added problem she had set herself of painting by lamplight. Her letter contains a clue to what may have been a partial solution. 'I paint my picture on the top of a hill', she wrote. Though the words could, in the context of the letter, refer to the location of her lodging, it may be that parts of the Toulouse pictures were painted out-of-doors.

Dorelia by lamplight at Toulouse belonged to Augustus John and was for many years a cherished element of the atmosphere in the famous dining-room at his home Fryern Court. It was first exhibited (as *Reading*, no. 34) in Gwen John's exhibition at the New Chenil Galleries in London in May-July 1926.

14. The student

Like the preceding picture, this portrait of Dorelia McNeill was painted at Toulouse during the winter of 1903–04. Dorelia remembered that the portraits were drawn directly onto the canvas without preliminary studies. The several drawings of Dorelia wearing the dress of this picture should be seen as separate works in their own right, rather than as preliminary studies for the paintings.

The student was not exhibited until 1909 when it appeared, as *L'étudiante*, in the winter exhibition of the New English Art Club (no. 51). It was singled out by Laurence Binyon writing in the *Saturday Review* (11 December 1909) as 'the most memorable thing in the whole exhibition'. This notice caught the eye of the American collector John Quinn in New York. Having heard of Gwen John's work through Augustus, whose pictures he had recently begun to buy, Quinn made an unsuccessful attempt to purchase *The student* sight unseen. It was the start of his important relationship with Gwen John as her patron. Quinn wrote to Augustus John (31 January 1910): 'Tell your sister I envy the man who got the picture'. The man was Charles Rutherston, who

had bought *The student* soon after the opening of the exhibition. He presented it to the City of Manchester Art Galleries in 1925.

15. Dorelia in a black dress

Like the two preceding pictures, this portrait of Dorelia McNeill was painted during the 'walk to Rome' in 1903-4. It is larger than any known picture by Gwen John up to this date. Sometime during the next few years it was acquired by Gwen John's friend Ursula Tyrwhitt in whose letters it is mentioned from time to time as a cherished possession. Late in 1911 Ursula Tyrwhitt was asked by Charles Aitken, the newly-appointed Director of the Tate Gallery, to lend the picture to an exhibition, organised by the Contemporary Art Society, to tour the provinces throughout the year 1912. This exhibition already included two Gwen John paintings recently presented by Aitken to the Society (see note to Pls 30 and 38). Ursula Tyrwhitt, fearing for its safety, was unwilling to part with the picture for a year. She suspected also, as she told Gwen John, that 'someone is sure to wish to take it from me.' In 1917 Aitken again approached her, suggesting that 'I should give up the portrait I have of yours and am so fond of to be hung in the "British Gallery of Art" (that atrocious building full of abominable paintings). I indignantly refused to give it up either from artistic, patriotic or mercenary sentiments – all of which he appealed to . . .'

By April 1926 Charles Aitken had so far prevailed, that the question of a price for the picture was being discussed with Ursula Tyrwhitt. 'Yes, sell it as well as you can,' Gwen John wrote to her, 'you need not have waited to ask me! (I don't think he will give £100!) I don't think it at all "commercial and sordid" to consider the price . . .' That summer the picture was shown in Gwen John's exhibition at the New Chenil Galleries in London (as *Dorelia*, no. 44) and letters in the Tate Gallery archive show that in September 1926 a final decision to purchase it was made by the Committee of the Duveen Fund – Charles Aitken, Muirhead Bone, Charles Holmes and Sir Robert Witt. The price paid was £200. On 8 November Charles Aitken wrote to Gwen John, 'We are so glad to have "Dorelia" in the sphere of this gallery . . . I find people most enthusiastic about your paintings here and increasingly so. Prince Paul of Serbia quite intelli-

gent for a royalty was full of admiration and wished he could get one. . . . With four we are not badly off here!'[8] Surprisingly for someone who seemed so appreciative of her work, Aitken asked in the same letter what she would think 'of our turning in two inches of canvas on the left. There seems too much space on that side of the figure'. The archive does not contain her reply but it seems unlikely that she would have agreed to such a proposal; and to judge by records in the Tate Gallery's conservation department the dimensions of the picture as we see it today are the original ones. At some point before the completion of the picture, Gwen John herself seems to have re-stretched the canvas at its lower edge and incorporated the extra half inch into the painting.

16. Woman asleep on a sofa

The woman is Dorelia McNeill. Two other versions of this drawing (in the National Museum of Wales, Cardiff) are more spare and stylised – the head treated almost like a mask in a manner reminiscent of Flaxman. In the Cardiff drawings Dorelia has not yet kicked off her shoes.

17. Cat cleaning itself (Edgar Quinet)

Gwen John arrived in Paris with Dorelia McNeill in the spring of 1904 and they installed themselves in the Hotel du Mont Blanc, Boulevard Edgar Quinet[9]. Soon afterwards they acquired a cat which was to be Gwen John's companion and principal model for the next four years. The cat was a female and some of the drawings show her with a kitten (she is known to have had a litter in the autumn of 1904 and another in 1906). She was known to Gwen John and her friends as Edgar Quinet and is frequently mentioned in their letters. She often appears as the principal protagonist in some tale of farce or mock drama. Gwen John described the cat to Rodin as having 'an independent and very stubborn character. . . . She understands everything I say to her (but) almost never obeys.' 'Give my love to Edgar Quinet,' Gwen

8. In 1926 the Tate Gallery owned (besides *Dorelia in a black dress*) three paintings: *Nude girl, A lady reading* and *Chloë Boughton-Leigh*.
9. Formerly the Boulevard Montrouge. In 1879 the name was changed in honour of the writer and historian Edgar Quinet (1803–75).

John's friend Grilda Boughton-Leigh wrote from Zermatt in June 1906. 'Is she as troublesome as ever?'

'I've got a cold caught in a delightful day by the river with Edgar Quinet when it rained in torrents,' Gwen told Dorelia in the autumn of 1904. Her correspondence of the period describes with some self-mockery her agonies at the cat's frequent disappearances in the course of similar outings, but there can be no doubt of the reality of her suffering when it was finally lost in 1908.

Gwen John left well over a hundred drawings of cats, many of them portraits of Edgar Quinet. The cat drawings are no less serious than her portraits.

19. Study of a cat (Edgar Quinet)

The drawings of Edgar Quinet were mostly done in pencil and watercolour, sometimes heightened with white. They were executed in several stages and almost all follow the same method. First the main form of the cat and the broad areas of fur colour are stated in rapid pencil outline. The basic fur and background colouring is then laid on in simple washes. Finally the cat's tortoise-shell markings and any background shadows are drawn in with the brush, in black. Sometimes there is a touch of colour in the eyes or nose. The background is always an integral part both of the explanation of the cat's form and of the design. This study has not been carried beyond the second stage but, in its perfect simplicity, must be considered complete.

20. Cat (Edgar Quinet)

There are several drawings of Edgar Quinet in this posture, e.g. Pl. 38, *A lady reading*, shows one on the background wall.

21. La chambre sur la cour (Girl sewing at a window)

Between the years 1905 and 1911 Gwen John made a number of paintings of the three rooms in the Montparnasse district of Paris which were successively her home. This picture was painted in the first of these, a room at 7 rue Ste Placide where, at Rodin's instigation, she had installed herself by November 1904 and where she lived until early in 1907. In letters to Rodin she expressed her intense pleasure in the room's appearance and atmosphere: 'It is so good here in the evening after I have

had supper, when everything is clean and tidy, a fire in the grate, some flowers on the mantelpiece and my little cat who is watching me from the bed . . .' After a day at work she found the room 'so charming . . . with my drawings on the walls, my books, and the furniture bright and clean and the clean curtains and the pink floor.' Later she spoke of the room's 'pretty wallpaper' and 'the courtyard for my little cat'. Gwen John's descriptions of this room are always related to herself and her own delight in it. The figure of the girl in this picture is a self-portrait. Domestic chores which included sewing and mending were among the chief occupations of her solitary hours and an important part of the constant creation of the room's ambience in which she took such pleasure and which is conveyed so strongly in the Rodin correspondence.

The picture has been known by various titles. It was first exhibited (together with the portrait of Chloë Boughton-Leigh, Pl. 34) at the New English Art Club spring 1908 exhibition (no. 109) as *La chambre sur la cour* and from there it was purchased by Sir Francis Darwin for £30. It passed from him to his daughter, the poet Frances Cornford. She lent it, as *Interior; girl at a window*, to the New English Art Club Special Retrospective Exhibition in 1925 (no. 79). It appeared in the 1968 Arts Council exhibition in London as *Girl sewing at a window* (no. 11), though the first printing of the catalogue wrongly listed it as *Girl reading at a window*.

22. A corner of the artist's room in Paris (with flowers)

Though sad to leave the room she found so charming in the rue Ste Placide, Gwen John soon became just as much attached to her new home – a room in the attic floor of the eighteenth century Hôtel de Montmorency at 87 rue du Cherche Midi. Writing to Rodin (?spring 1907) she said: 'I must tell you . . . what a feeling of contentment my room gives me. I take my meals at the table in the window . . . In the evening my room gives me a quite extraordinary feeling of pleasure. I see the wide sky. This evening it is tender and calm. And the trees that I can see seem, in the nights like a great forest . . .' Gwen John lived in the rue du Cherche Midi from March 1907 till the autumn of 1909. The room still exists, though the sloping ceiling was removed and the window altered in the course of roof repair work soon after the First World War. The wicker chair, which features in so many of Gwen John's pictures, was preserved for some years after her death by her nephew Edwin John whom she had made her heir; it finally disintegrated, eaten away by woodworm.

Gwen John seems never to have parted with this picture or even to have exhibited it. It was shown in the 1946 Memorial Exhibition in London (no. 5) and from that exhibition was given by Edwin John to Dorelia. She in turn presented it to Sheffield in 1964 in appreciation of their 1956 Augustus John exhibition.

In 1983 the Graves Art Gallery kindly allowed me to make a copy of this picture. I was surprised by the very extensive use of Naples yellow in the painting, though that is a colour often mentioned in Gwen John's later notebooks. Naples yellow appears most obviously in the painting of the chair, the parasol handle and the flowers, as well as in the triangular wall of the window embrasure. But it is also the opaque agent in the mysterious shadowed area of the sloping wall and it is an essential ingredient of the colour of the terra-cotta tiles which are made up of complicated layers and mixtures of Naples yellow, black, vermilion and alizarin crimson. The brushes used are mostly (perhaps all) sable, and are small – going as far down the scale as 00. Gwen John's increasing interest in the use of large shapes and angular patterns is everywhere apparent in this picture.

23. A corner of the artist's room in Paris (with book)

This version of *A corner of the artist's room in Paris*, with its open window and leafy tree, seems to have been painted in summer (the primroses in the version with flowers indicate a date in spring). The stylisation apparent in the version with flowers is carried here a stage further and it seems likely that this was the later painting of the two.

This picture, like its companion, was not sold or, apparently, exhibited until after Gwen John's death.

24. The artist in her room in Paris

Though more frankly a self-portrait than Gwen John's other paintings of herself in her room, this picture is nonetheless characteristic in its rejection of the rhetorical self-portrait image.

The shapes made by the buildings and sky seen through

the window are, as might be expected, the reverse of those in the paintings *A corner of the artist's room in Paris* (Pls 22, 23). The position of the bed however is inconsistent with a mirror-image. This self-portrait, the nude drawings (Pls 26, 27) and the painting of the room (Pl. 22) all look like statements of direct observation. It seems therefore that at some point the furniture was moved.

The picture was acquired by Augustus John and for many years it hung at Fryern Court. It was exhibited for the first time in the 1946 Memorial Exhibition in London (no. 42, ill.).

25. Self-portrait with a letter

Soon after her arrival in Paris in March 1904 Gwen John found employment as an artists' model. 'I hope you are careful to pose only to your young artists', Augustus wrote to her soon afterwards. 'Why not call on Rodin. He loves English young ladies'.[10] It was in the studio of the Finnish sculptor Hilde Flodin (one of Rodin's *praticiens*) that Gwen John first met Rodin in the summer of 1904. He employed Gwen as a model and shortly afterwards they become lovers. For thirteen years, until Rodin's death in 1917, this relationship dominated Gwen John's life. Her passionate love for Rodin and her own obsession with that passion found expression in the letters she wrote to him almost daily during the earlier years of their liaison and continued to write at intervals until his death. Often she delivered her letters by hand to his studio at 182 rue de l'Université and (from 1910 onwards) at the Hôtel Biron in the rue de Varenne. That building is now the Musée Rodin and it is there that her letters to Rodin are kept today, together with a number of drawings of the cat Edgar Quinet, a self-portrait drawing and *Self-portrait with a letter*. Gwen John alludes to these gifts in her letters, but always in the context of 'bringing a little drawing' to prove to him that she had not been idle, never to present herself to him as an artist – far less as an artist of great talent and some reputation. Though Rodin complimented her on her ability[11] it seems likely that he never realised her stature or understood that in her he had to do with someone whose

work was sought after along with that of some of the greatest artists of the day. It may be that she never showed him her paintings – the tiny canvases were, after all, small enough to be kept out of sight, even in her one-room dwelling. *Self-portrait with a letter*, the most substantial of her pictures that he must certainly have seen, has about it so much of stark and uncompromising autobiography that it might be difficult to measure her talent by it, in spite of its undoubted power. As a picture it is unique in her œuvre – the only highly finished and detailed watercolour portrait she is known to have produced.

26. Self-portrait nude, sitting on a bed

From the time of her arrival in Paris in 1904 Gwen John earned her living as an artists' model so that when she made use of herself as a sitter it would have seemed to her as normal to pose nude as clothed. She does seem however to have regarded these and her other self-portrait nude drawings as private studies and they were not sold or exhibited in her lifetime. To some extent also, these drawings were experimental: they are among her first essays in the use of gouache. This may be one reason why this drawing remained unfinished.

27. Self-portrait nude, sketching

One of eight almost identical in the Cardiff collection, this drawing may be connected with those referred to in a letter from Gwen John to Ursula Tyrwhitt (15 February 1909): 'I am doing some drawings in my glass, myself & the room, & I put white in the colour so it is like painting in oil & quicker. I have begun 5. I first draw in the thing then trace it on to a clean piece of paper by holding it against the window. . . .' It has been pointed out by A. D. Fraser Jenkins[12] that at least one of the series to which this drawing belongs appears to be a tracing. Other drawings show Gwen John in the same room seated, nude, on the bed (cf. Pl. 26). Letters to

10. Undated letter March–April 1904 from Matching Green, Essex.

11. ' "Vous êtes bel artiste" were his words, which she reported to me with natural elation', Augustus John wrote in his introduction to the catalogue of the 1946 Memorial Exhibition.

12. *Gwen John at the National Museum of Wales*, 1976, pl. 5 note.

Rodin from this period also talk of 'drawing myself nude in the glass.' These drawings and also the painting of herself which she made in this room (at 87 rue du Cherche Midi) have a less impersonal quality than those which show her in her rooms at rue Ste Placide and at rue de l'Ouest (Pls 21, 24, 26, 38, 39).

28. Portrait of a lady

There are at least nine drawings of this unidentified sitter.[13] All nine are drawn in a free and rapid pencil line with the addition, in all except one, of black and grey wash. In six of the drawings the lady[14] is wearing the blouse and black scarf shown here. In every case her pose is different.

30. Nude girl

The model for this picture and its companion *Girl with bare shoulders* (Pl. 31) was an English girl who passed herself off as a gypsy and assumed the gypsy name of Fenella Lovell. According to Augustus John, for whom she also posed, she had 'learnt a considerable lot of the Romani language in which she used to write to me, mixing her dialects recklessly'.[15] The writer Arthur Symons, however, was much impressed by her mastery of the language in which she instructed him during a stay at his home in Kent shortly before this picture was begun. In 1909–11 Fenella Lovell was in Paris working as an artists' model. She was one of the many young women who attached themselves to the circle surrounding Rodin and his *atelier* and she posed for him from time to time. Gwen John eventually had reason to believe that Fenella was trying to usurp her as Rodin's model for the Whistler

Monument. Gwen John seems to have been working on her Fenella Lovell pictures between September 1909 and April 1911. Their history is complicated by the fact that the frequent references to them in her letters make no distinction between the nude and the clothed version (she uses the word 'portrait' in connection with both). The greater spontaneity of the *Nude girl* suggests that it was the version of which, mentioning Fenella's name for the first time, she wrote confidently to Ursula Tyrwhitt (30 September 1909): 'I have done quite quickly the portrait of Fenella – It is nearly finished I think. I think it will be good and principally because I have not thought about it being seen by anybody.' Inevitably, this initial enthusiasm evaporated. By February 1910 she was writing that she felt 'cold' towards painting Fenella, whose flamboyance and play-acting began to grate unbearably on her nerves. 'That little creature Fenella,' she told Ursula Tyrwhitt, (6 May 1910), 'you cannot imagine, or perhaps you can, what a bore she is . . . old fashioned in a horrid way, a sort of copy.'

In the autumn of 1910 Gwen John was in correspondence with the artist Muirhead Bone (he sent her 'quite a polite letter – considering his name') who hoped to buy one of her pictures. In the event, he purchased at least two paintings and Ursula Tyrwhitt wrote approvingly: 'I am so glad you finished the paintings. . . . Mr Bone ceases to be what I thought if he can appreciate them.' (15 April 1911). It seems highly probable that the pictures purchased by Muirhead Bone were the *Nude girl* and *A lady reading* (Pl. 38). These were presented on 4 May 1911[16] to the Contemporary Art Society by Bone's friend Charles Aitken who was soon to take up the post of Director of the National Gallery of British Art (the Tate Gallery). It has been recorded by Mary Chamot[17], formerly on the staff of the Tate Gallery, and the first critic to write at length about Gwen John, that 'when Mr Charles Aitken left the Whitechapel Art Gallery to take up his duties as Director of the National Gallery of British Art his friends wished to make him a little present as a remembrance, and asked him what he would like. He chose these two little pictures by Gwen John, and at

13. Retrospective Exhibition 1968, nos 59, 60, 61 and 59n.; coll. National Museum of Wales, Cardiff; coll. Borough of Swindon (this picture); two more are in private collections; and one other is reproduced at Pl. 29.

14. Drawings of this sitter were given the title *Portrait of a lady* by Mrs Stefanie Maison who has been associated with most of the important exhibitions of Gwen John's work since it was first given a major showing at the Memorial Exhibition held at the Matthiesen Gallery, London, in the autumn of 1946. All Gwen John's other unidentified female sitters have been called 'women' or 'girls'.

15. John Rothenstein, *Time's Thievish Progress*, London 1970, p. 22.

16. The C.A.S. minutes for the meeting of that date record the pictures under the titles *The model* and *Interior*.

17. *Country Life*, 5 June 1926, p. 771.

once presented them to the new gallery under his care that the public might share in his enjoyment of them.' The pictures were officially passed from the Contemporary Art Society to the Tate Gallery in 1917.

The Contemporary Art Society's pictures were shown publicly for the first time in an exhibition which toured the provinces for just over a year from December 1911. A letter from Gwen John to Rainer Maria Rilke dated 6 December seems to belong to this year. 'The portrait I did of Fenella' she wrote, 'has had some success in London. Fenella has received some letters from artists and I too have had letters from artists and it has been put in an exhibition.' The opinion of fellow-artists meant much to Gwen John, and one of those who thought highly of the *Nude girl* and *A lady reading* was Henry Lamb. When the Contemporary Art Society's pictures were later shown in London at the Goupil Gallery, Lamb commented in a letter to Lytton Strachey (8 April 1913): 'The C.A.S. show is a depressing affair. Tout le monde en sort mal – except only Gwen John.'

31. Girl with bare shoulders

The feelings of antipathy aroused in Gwen John by Fenella Lovell are apparent in her paintings of this model and are reflected too in her attitude to the pictures themselves, which came to seem to her, at times, as hateful as the sitter. This may partly account for the fact that *Girl with bare shoulders* remained unsold during Gwen John's lifetime.

The Fenella Lovell pictures preoccupied Gwen John during the first half of 1910. In May of that year, in connection with the New English Art Club summer exhibition, she wrote to Ursula Tyrwhitt: 'Why I want to send two paintings is because I may then sell one and then I shall pay (Fenella) what I owe her and never see her again'; and indeed two pictures by Gwen John – *Les pêcheurs* and *A portrait* – were shown in the exhibition. *Les pêcheurs* was sold to an unknown buyer; *A portrait* seems to have remained unsold[18] and all the evidence sug-

gests that it was the picture now known as *Girl with bare shoulders*. From New York, John Quinn, who as yet owned nothing by Gwen John, went to some lengths to buy the two paintings by her in that exhibition, as his correspondence with Augustus John reveals, and for a time he believed that he had secured at least one of them. The cheque he despatched in payment for it (29 July 1910) crossed with Gwen John's letter to him (28 July 1910) which read: 'I am afraid you must wonder why the picture you ordered has not yet arrived. I have been a long time trying to decide whether I should send it and now I have decided not to send it. People say it is so ugly I am sure it is'. In December 1910, Gwen John's elder brother Thornton, visiting her from London, 'brought back my portrait of Fenella and I shall finish that when I have the energie. It was silly of me to send it, it looks dreadful I think though I have not dared to look at it yet – but what I can remember of it' (Gwen John to Ursula Tyrwhitt, 21 December). The painting seems not to have been seen again until it appeared as *Three-quarter length of a girl with bare shoulders* (no. 13) in the Gwen John Memorial Exhibition held in London at the Matthiesen Gallery in 1946.

In 1953 I obtained from Matthiesen a photograph of the picture taken at the time of the 1946 exhibition. This photograph (Fig. 4) shows that the picture has since been cruelly and damagingly restored, and the lower right-hand section repainted without regard to either the style or the composition of the original.

32. Chloë Boughton-Leigh

See also Pls 33, 34, 35. Ellen Theodosia Boughton-Leigh (1868–1947), known to her friends as Chloë, was the daughter of Edward Boughton-Leigh of Brownsover House near Rugby. She and her younger sister Maude (Grilda) studied at the Slade; and later both sisters made periodic prolonged visits to Paris. It was during some of these Paris visits that Gwen John painted three portraits and made a number of drawings of Chloë. Gwen John

18. There are no known official records of sales from New English Art Club exhibitions of this period. A summer 1910 exhibition catalogue belonging to the Federation of British Artists contains some notes of sales and prices in a contem-

porary hand. Against the entry no. 30, *Les pêcheurs*, is written '£50 – sold'; against the entry no. 231, *A portrait*, is written '£50'. The present whereabouts of *Les pêcheurs* is unknown.

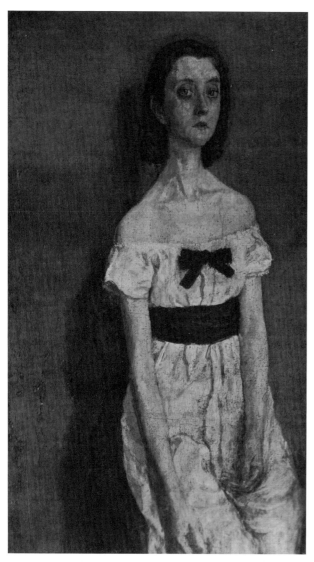

Fig. 4. *Girl with bare shoulders* (see Pl. 31). A photograph dating from 1946.

ing the care of her cats, and making practical gifts of tea and clothes. She kept Gwen John supplied with books, among them *Jude the Obscure* ('such a *very* depressing book but you said you would like to read it'); Katherine Mansfield's *Journal* ('rather expensive' at fifteen shillings); and *Lady Chatterley's Lover* ('some part of it had to be left out. I don't suppose it really matters at all').[20]

From the time of the 1946 Memorial Exhibition until 1968, this and other drawings of Chloë Boughton-Leigh were known as portrait-studies of Fenella Lovell (the model for the paintings *Nude girl* and *Girl with bare shoulders*, Pls 30, 31). It appears that Gwen John made no drawings of Fenella Lovell.

34. Chloë Boughton-Leigh (with loose hair)

See note to Pl. 32. Gwen John painted three portraits of Chloë Boughton-Leigh – of which this is the earliest (cf. Pl. 35).[21] It was exhibited at the New English Art Club, spring 1908 (no. 78) along with *La Chambre sur la cour* (Pl. 21) – the first pictures Gwen John had shown since the New English Art Club winter exhibition of 1902 – and was purchased (for £15) by the sitter. It is difficult to explain the unfinished hands in a portrait submitted for exhibition after a gap of so many years. Gwen John is known to have spent months working on paintings before being satisfied that they were ready to be shown. Perhaps at some time after its purchase the picture was returned to her for a further reworking which was never completed. Chloë Boughton-Leigh is known to have been self-conscious about her hands. A letter to Gwen John dated 25 February (?1919) contains the remark: 'If you saw my hands I am sure you would not *think* of wanting me for a model. They are simply fearful. I don't think they were ever very respectable but they really wouldn't do to paint now at all'. It seems likely that the three-quarters of an inch strip of wood by which

herself was employed as a model by Grilda Boughton-Leigh.[19]

Chloë Boughton-Leigh kept up a lifelong correspondence with Gwen John, advising on matters regarding her health, transmitting messages from Grilda concern-

19. Grilda Boughton-Leigh was an artist of some talent. A portrait by her of her sister Chloë was acquired in 1947 by the Tate Gallery in the mistaken belief that it was a self-portrait by Gwen John. No picture by Grilda Boughton-Leigh showing Gwen John as her model has come to light.
20. Presumably the expurgated edition of 1932.
21. The portrait, known as *Woman holding a flower*, belongs to the Birmingham City Museum and Art Gallery.

the canvas has been enlarged at the bottom was added at an earlier stage of the picture's evolution; a similar lengthening of the canvas (this time by restretching) can be seen in the second portrait of this sitter (Pl. 35).

The picture was lent by Chloë Boughton-Leigh to the New English Art Club's Special Retrospective Exhibiton in 1925 (*Portrait*, no. 76) and, having been noticed there, it was bought soon afterwards by the Tate Gallery.[22] Chloë Boughton-Leigh generously handed over the profit to Gwen John who, largely because of this money, was able to purchase the piece of land and later have constructed the little chalet at 8 rue Babie, Meudon where, surrounded by trees and garden, she spent the last years of her life.

35. Chloë Boughton-Leigh (with her hair in a bun)

See also Pls 32, 33, 34. Throughout the year 1910 Gwen John's letters convey a sense of dissatisfaction with earlier work and of struggle to break new ground; and her portraits of this period show a gradual shift towards a new simplicity and monumentality. Associated with this is a change in the pigment itself – a change which can be seen happening within this portrait. The figure, for all its new massive simplicity, is still drawn with a nervous brush, though the paint is drier than before. But areas of the background begin to be built up with that mosaic of opaque pigment which is characteristic of much of Gwen John's later work.

In mid-September 1910, Gwen John wrote to Ursula Tyrwhitt: 'I have been so dreadfully pressé lately because Miss Leigh whom I painted before is here for three weeks only, and expects me to do her portrait in that time. I am trying but perhaps it will not be good as everything that I do has to grow slowly'; and two months later: 'I am posing now and not painting at all. I got so tired over Miss Leigh's portrait – they kept me at it too long and were always hurrying me. At last I could not go on any longer and I stopped and refused to send it to the N[ew] E[nglish]' (21 November 1910).

The portrait was finally finished almost four years after it had been begun. In July 1914 it was despatched, not to the Boughton-Leigh sisters who had commissioned it, but to John Quinn – the second picture by Gwen John he

acquired. Her letters to him throughout the previous year reflect something of her unease as, at intervals, she continued to work on this transitional painting. But on 27 September 1914 she was able to report to Ursula Tyrwhitt: 'I had a letter from Mr Quinn and my picture and drawings[23] are very much admired. That has given me great pleasure as I was rather anxious about them as they are so different from the others.'

After the death of John Quinn in 1924 the Boughton-Leigh sisters had the picture purchased from the final auction of his collection (American Art Association, Inc., New York, 1927; no. 344) and it was bequeathed by them to their cousin Mrs Sylvia Molloy who (through Matthiesen) sold it to the Leeds City Art Gallery in 1955.

36. Black cat on blue against a pink background

Nothing is known about the cat in this picture though some other drawings of a black cat exist (Memorial Exhibition 1946 no. 188); and a large black cat appears in at least four paintings (see Pl. 48). Following the disappearance in 1908 of her cat Edgar Quinet, Gwen John refused for a time to own another. 'No, don't bring me a kitten,' she wrote to Ursula Tyrwhitt (15 February 1909), 'I don't want to get attached to a little beast again as I did before . . . I think I should put all that energy of loving into my drawings don't you?' Though eventually she owned a number of other cats, the profusion of important drawings which Edgar Quinet's presence had inspire was never repeated. The stylisation of this drawing, with its large simple shapes and flat washes of colour, seems to link it with work like the *Little girl in a large hat* (Pl. 37) and suggests a Japanese influence.

37. Little girl with a large hat

In 1908 Gwen John began to experiment with the medium of gouache. She worked systematically on a number of almost identical pictures traced from the original drawing (see note to Pl. 27). Writing to Ursula Tyrwhitt (15 February 1909) she described her method: 'Decide absolutely on the tones, then try and make them in colour and put them in flat', and commented 'I want

22. Mary Chamot, *Country Life*, 5 June 1926, p. 771.

23. Along with the portrait, Gwen John sent two drawings of Chloë Boughton-Leigh.

my drawings, if they are drawings, to be definite and clean like Japanese drawings'. *Little girl with a large hat* is one of a set of eight drawings which can be associated with these experiments.

Two of the drawings from this set were presented by Gwen John to her friend Véra Oumançoff in the late 1920s. An inscription in Gwen John's hand on the back of the mount of one of them describes the subject as 'petite fille dans le train.' Gwen John is known to have been interested in Japanese art. In an early (undated) letter to Rodin, she talks with pleasure of the prospect of seeing some Japanese prints in his collection (see also note to Pl. 61).

38. A lady reading

Because of their subject-matter, this picture and its companion in the Museum of Modern Art, New York (Pl. 39) have been previously linked with *La chambre sur la cour* (Pl. 21) which was painted at 7 rue Ste Placide. But the wallpaper and the height of the window from floor level indicate that the location is a different one – the room at 6 rue de l'Ouest where Gwen John had installed herself by the autumn of 1909. The window in the rue de l'Ouest room was very similar to the window shown here. The picture's history, too, suggests a date when Gwen John was living in the rue de l'Ouest – the winter of 1910–11. During that period her letters to Ursula Tyrwhitt show that she was at work on a picture (or pictures) for the English artist Muirhead Bone, and it seems likely that it was he who purchased *A lady reading* in the spring of 1911. On 4 May of that year, the picture (under the title *Interior*) was presented to the Contemporary Art Society by Charles Aitken who was a friend of Bone's (see note to Pl. 30).

Though the figure in *A lady reading* is in some respects a self-portrait, Gwen John is consciously experimenting here with a new kind of stylisation. On 15 October 1911 she wrote to Ursula Tyrwhitt, who had recently seen the picture: 'How dreadful that you should think that the girl is sitting on the table and that she is me. . . . You are so right about that head. I tried to make it look like a vierge of Dürer, it was a very silly thing to do. I did it because I didn't want to have my own face there. The picture I have done for Mr Quinn is the same pose and I have put my own face in it and it is more fitting' (see

Pl. 39). The pictures of cats on the wall are studies of Edgar Quinet (cf. Pl. 20).

No. 6 rue de l'Ouest was situated just off the Avenue du Maine and within a few hundred yards of the Gare Montparnasse. In 1910 it consisted of four shops – a bakery, a printer's, a butcher's and a laundry – and above them, on two floors, a network of single lodging-rooms leading off two long corridors, each with its communal lavatory and single communal water-tap. Gwen John's room was at the rear of the building and overlooked a charming cobbled square known locally as the Cour des Miracles (in affectionate reference to the legendary place of that name north of the river, beyond Notre Dame). The *cour* was filled with little workshops and studios which stretched across to the back of the neighbouring rue Vercingétorix. Gwen John may have been unaware of the fact that she looked out on a site rich in recent artistic history. Across the little square from her own house, at no. 6 rue Vercingétorix, Gauguin had lived in 1894–5; and in the same house the artist William Molard and his Swedish wife, the sculptor Ida Ericson, kept open house for artists and musicians in the 1890s. Munch, Greig and Strindberg spent time there and Delius and Ravel were frequent visitors.[24] Within the *cour* itself, the Douanier Rousseau had had a studio and it was here, in 1897, that he had painted *The sleeping gypsy*.[25]

Gwen John retained her room in the rue de l'Ouest until the autumn of 1918 and used it as a studio after she had moved to the suburb of Meudon early in 1911. Until the mid-1970s the Cour des Miracles and the houses surrounding it remained intact, with the rooms at 6 rue de l'Ouest still in use exactly as they had been in Gwen John's day; and the studios and workshops of the Cour des Miracles still housed a close-knit population of artists and artisans. Today not one of these buildings remains. The entire site is now covered by a large shopping complex and a fifteen storey block of flats.

24. A detailed account of the Molard circle and the life at 6 rue Vercingétorix in the mid-1890s is given in *Delius, the Paris Years* by Lionel Carley, Triad Press, London 1975, pp. 45–62.
25. An arched gateway at 3 rue Vercingétorix was the main entrance to the Cour des Miracles and this was the address of the Douanier Rousseau's studio.

39. Girl reading at the window

See also Pl. 38 and note. The American collector John Quinn who, without ever having seen a picture by Gwen John, had been anxious to acquire her work since 1909[26] succeeded at last when *Girl reading at the window* was delivered to him early in 1913. Having received a cheque from Quinn in July 1910 for a picture which she did not send, Gwen John began work on this painting which was intended specifically for him, and by Christmas was writing to tell him 'I am not yet satisfied with what I have done'. It was not until 22 August 1911 that she was able to tell Quinn that the picture was finished, adding 'I have done what you said I may do – taken my time over it. I have enjoyed doing it for that reason.' She was anxious to exhibit the picture, however, before despatching it to Quinn, so that she might learn, as she wrote to Ursula Tyrwhitt, 'what it appeared like to people'; and it was shown that autumn at the New English Art Club in London (no. 58). 'I have had several press notices about it,' she told Quinn (28 November 1911), 'I don't quite know what that means but I suppose it means something.' A letter from Ursula Tyrwhitt should have been reassuring: 'Your little picture is very well hung and much admired. It did not want any varnish. Ambrose McEvoy whose advice I asked said "Don't touch it. It is most awfully good." I think it is so like you and altogether delightful. Mary [McEvoy] and Ambrose and I stood looking at it and others came up behind and we were quite a crowd all feeling so much pleasure from the sight of it' (26 November 1911).

But Gwen John, whose style was about to undergo a major change, felt increasingly uneasy about the picture. Even before Quinn had received it she was hoping that it 'is now at the bottom of the sea with the Titanic. It is not as I want to paint . . . I like (it) so little now that I hope I shall not hear of it again except to hear that you have not received it and never will' (5 August 1912).[27] Quinn, to use his own words, 'fell in love with the picture' as

Fig. 5. The Cour des Miracles. Gwen John's white-framed window can be seen on the first (middle) floor of the building at the far end facing the camera. The Douanier Rousseau's studio was in one of the buildings to the left of the picture.

soon as he saw it.[28] For him it was 'a perfect little gem'. Within less than a month of its arrival in New York he had lent it, along with paintings by Puvis de Chavannes, Cézanne, Van Gogh and Gauguin among others, to the now famous International Exhibition of Modern Art (the Armory Show) – the first important exhibition of advanced contemporary painting and sculpture to be shown

26. His letters to Augustus John show that he tried to buy her pictures at the New English Art Club exhibitions of winter 1909 and summer 1910. See notes to Pls 14 and 31.
27. The *Titanic* was lost on 15 April 1912 and with it a consignment addressed to Quinn which included the manuscript of Joseph Conrad's story 'Karain'.

28. The picture was not despatched to him until January 1913. He first saw it during a visit to London in the autumn of 1912.

in the United States; and he made strenuous last-minute efforts to get her to send other examples of her work for inclusion in the show. 'Send anything you can', he wrote (14 January 1913). But the one picture she then promised was never sent (see note to Pl. 54).

40. Mère Poussepin

See also Pl. 41 and note. In the winter of 1912–13, two years after moving to the village-suburb of Meudon, Gwen John was received into the Catholic Church. She came to know some of the Dominican Sisters of Charity with whom she worshipped there, and agreed to paint for them a portrait of their founder Marie Poussepin. The biographical note below[29] is a translated extract from a memorial card published in 1911 by the Mother House of the Congregation at Tours.

A contemporary portrait of Marie Poussepin (Fig. 6) owned by the Mother House is the only portrait officially considered authentic – all others being copies or reproductions based on this original image.[30] The portrait was preserved during the period of the Revolution by the family of one of the nuns and was restored to the Mother House in the mid-nineteenth century. In 1894 it was published for the first time in a biography of Marie Poussepin by Canon Poüan. The memorial card published in 1911 bore a small engraved portrait (Fig. 7) based closely on the original picture. These reproductions were the models available to Gwen John for her portrait.[31]

The problem of enlargement which Gwen John had to deal with was compounded by the fact that she chose to paint the picture on what was, for her, a grand scale,[32]

29. Marie Poussepin, Founder of the Congregation of the Dominican Sisters of Charity of the Presentation of the Blessed Virgin, was born into a respected Christian family at Dourdan in the diocese of Chartres on 14 October 1653.

From her youth, her thoughts were turned towards religion and she became a member of the Third Order of St Dominic. But following the death of her mother, she remained within the family home where her selflessness and love of duty led her to abandon all thought of her own aspirations.

At the age of 31 she found herself at last free to embark upon the practice of the holy work to which she aspired – the education of the daughters of the common people and the care of the poor and the sick.

Like the founders of all religious Orders, the Holy Mother had to suffer all manner of painful setbacks and difficulties which she overcame with great patience and tenacity. After fifty-four years of unremitting effort and unshakeable faith in God she at last saw the establishment of this Congregation which is now spread throughout Europe and the New World.

On 24 January 1744, full of years and virtue, she died in the ninety-first year of her age. Her remains now rest in the church of the Mother House of her Congregation at Tours.

30. In this portrait she wears a variation of the peasant costume worn in the Beauce region of France which was the country of her origin. Marie Poussepin adopted the white robe and black apron appropriate to the Dominican Order in place of the dark colour worn by the peasant women. Her coif resembles the *coiffe beauceronne* but lacks its ornamentation of lace.

31. The original portrait owned by the Mother House at Tours measures $30\frac{1}{4} \times 25\frac{1}{4}$ in. The biography reproduction measures $5 \times 3\frac{1}{2}$ in.; that of the memorial card $2\frac{1}{4} \times 1\frac{1}{2}$ in. Both were in black and white. Sœur Madeleine St Jean, archivist to the Mother House of the Congregation, believes that there could have been no actual-size reproductions at Meudon in Gwen John's time.

32. The size of the canvas in itself was the cause of further problems. Gwen John later wrote: 'I can only do little pictures here because of the light and the low ceiling. I had to go to Brittany to do Mère Poussepin' (undated fragment of the draft of a letter, ?1927).

33. They are: the two versions reproduced in this book (Pls 40 and 41): *Mère Poussepin* (seated at a table) ($34\frac{1}{2} \times 26$ in.) formerly in the collection of John Quinn, lent anonymously to the Stanford University Museum of Art Gwen John exhibition, Stanford, California, 1982 (no. 5, ill.); *Mère Poussepin* (seated at a table) ($23\frac{1}{2} \times 15\frac{1}{4}$ in.), lent anonymously to the Arts Council Gwen John Retrospective Exhibition, London 1968 (no. 23); *Mère Poussepin* (hands in lap) (23×14 in.), lent by Mrs Hugo Pitman to the Arts Council Gwen John Retrospective Exhibition, London 1968 (no. 24), now in a private collection; *Mère Poussepin* (hands in lap) (27×20 in.), Southampton Art Gallery. A portrait of Mère Poussepin was shown at the Salon d'Automne 1919 (976) and may have been one of these six, or a seventh version.

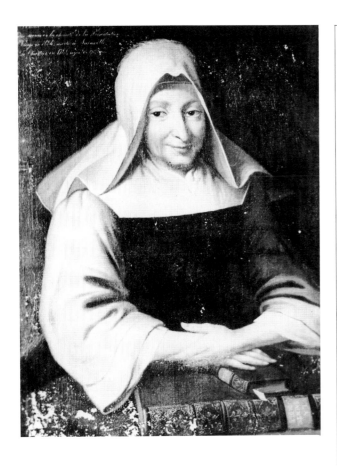

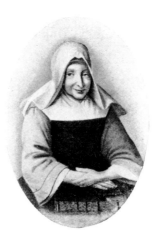

Marie Poussepin a saintement fourni sa carrière. Sa course a été lumineuse, revêtant de splendeur l'austérité du devoir, embellissant tout, jusqu'aux tristes mystères de l'indigence, de l'infirmité, de la mort. Par elle les horizons de la charité se sont agrandis, irradiés de lueurs et de grâces nouvelles. Sa charité a consolé la terre, et par elle, bien des siècles après son trépas, les corps auront leur soulagement, et les âmes leur saint réconfort.

Vie de la V. Mère M. POUSSEPIN.

Fig. 6. Marie Poussepin: the eighteenth-century portrait.

Fig. 7. Marie Poussepin: the memorial card of 1911.

and the difficulties she experienced, as well as her obsessive commitment to the task, are reflected in her correspondence. 'What a pity you cannot finish your portrait of the nun', her friend Grilda Boughton-Leigh wrote to her in July 1914. 'Surely it would be best to leave it and take a change'. And throughout the next few years the 'portrait of the nun' was invoked as Gwen John's constant excuse to John Quinn for her inability to complete the paintings he was hoping for. The nuns themselves

troubled her. 'I fell into a discouragement about my work and felt the nuns' contempt again' she told Quinn (17 August 1915). To make matters worse, by the following year, they wanted 'one for every room and I tried to do them all at the same time'.

Six portraits of Marie Poussepin are known to exist today.[33] Three of them show her seated at a table; in the other three she is seated against a plain background, her hands folded in her lap (cf. Pl. 41). Of these six portraits

Fig. 8. *Mère Poussepin* (seated at a table). Formerly in the collection of John Quinn.

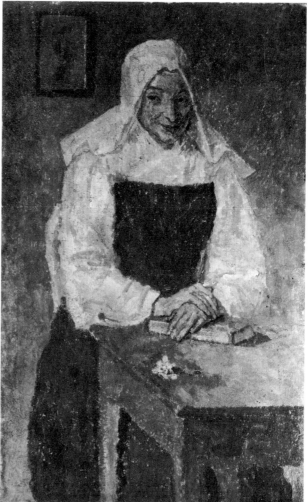

Fig. 9. *Mère Poussepin* (seated at a table). Exhibited at the Arts Council Gwen John Retrospective Exhibition 1968.

only one was eventually owned by the Convent (Fig. 8). In size, composition and execution it is close to the one reproduced as Pl. 40 in this book and which now belongs to the National Museum of Wales, Cardiff. The other four were painted on a smaller scale, though all are among Gwen John's larger canvases. The Convent picture was bought from the nuns by John Quinn in summer 1921. All the others remained unsold in her lifetime though her 1926 exhibition in London included the Cardiff picture

as well as an example of the simplified version. They appeared in the 1926 exhibition catalogue as nos. 39 and 25 respectively.

Whatever her earlier misgivings about the portraits of Marie Poussepin, Gwen John seems in the end to have felt that, in the case of one of them at least, she had triumphed over all the difficulties. When the Convent painting was awaiting shipment to New York along with a number of John Quinn's other purchases (they included

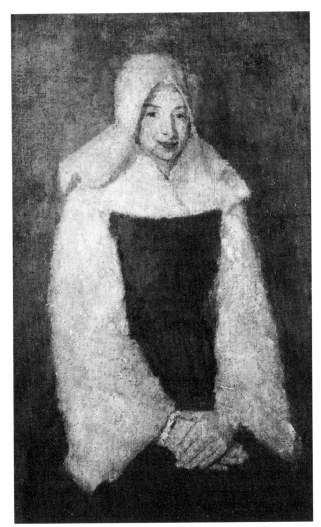

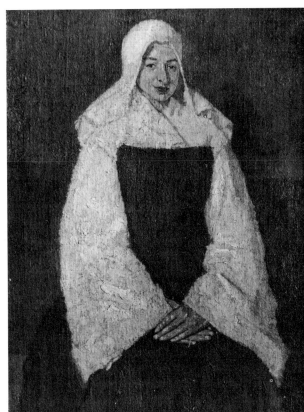

Fig. 11. *Mère Poussepin* (hands in lap). Southampton Art Gallery.

Fig. 10. *Mère Poussepin* (hands in lap). Exhibited at the Arts Council Gwen John Retrospective Exhibition 1968.

work by Picasso, Derain, Seurat, Segonzac and Matisse), she went to have a final look at it. Later she wrote to him (9 May 1922): 'I was very pleased and proud of my Mère Poussepin. I thought it the best picture there, but I liked the Seurat landscape.'

41. Mère Poussepin (hands in lap)

See also Pls 40, 42, 43, and notes. It will perhaps never be known in what sequence the portraits of Marie Pous-

sepin were produced. Gwen John's own words 'I tried to do them all at the same time', and the fact that in letters she refers to this series as if it were one picture, indicate that she worked on them all simultaneously. Nevertheless the evidence of the pictures themselves suggests that the image of Mère Poussepin 'hands in lap' can be thought of as a second stage in the development of an idea. In comparison with Pl. 40 it is at a farther remove from the model from which both pictures ultimately derive – the

123

eighteenth century portrait; and in its lack of extraneous detail and the grandeur and simplicity of its design it is characteristic of the kind of image with which Gwen John was increasingly engaged in the years following 1913.

One piece of documentary evidence which throws some light on the circumstances of the production of the pictures was 'set down at top speed' by her friend Jeanne Foster[34] after a conversation with Gwen John, and in spite of its over-emotional tone it can be assumed to reflect, at least to some degree, Gwen John's own account of the matter: 'She started to study, starved herself to hire models, painted – painted – painted. The convent refused to loan her a nun's costume. She bought the cloth and had one made. Twice it was ripped apart and remade before it was right. Then she pretended to work very slowly. She painted and repainted seven Mère Poussepins, hiding or destroying all of them. Seven years of agony passed. She never had a portrait that she dared show the priest. Finally he lost patience and said: "Are you or are you not going to paint Mère Poussepin?" Then desperately she began this painting and the miracle happened – the technique born of seven years travail and grief and love had been perfected – she was an artist.'

Given the lifelike quality of the Poussepin figures it is not surprising to learn that Gwen John made use of a living model in their creation; though the strength of the subject's vividly-realised personality springs above all from an intense act of sympathetic imagination. And, for all the rhetoric, Jeanne Foster is another witness to Gwen John's obstinate perfectionism.

42. A young nun

In addition to the portraits of Mère Marie Poussepin (Pls 40, 41) there exist at least eleven other portraits of nuns, all of them linked to the Poussepin image which they resemble closely in pose and in dress. Two sitters are depicted in these eleven portraits. The subject of Plate 42 has been portrayed three times, each time in the same posture – sitting stiffly upright, her hands in her lap. The sitter for the other eight portraits (Pl. 43) is shown always in a posture like that of *Mère Poussepin* (seated at a table). Whether these portraits of nuns were part of the evolution of the Poussepin portrait, or whether they themselves evolved from it, remains open to question. Some further details are relevant.

At the time of Gwen John's association with the Sisters of Charity at Meudon their dress resembled that of their founder Marie Poussepin with the important exception of the veil which, in the course of centuries, had been transformed into a starched and stiffened cornette. This distinctive and beautiful headdress can be seen in Gwen John's drawings of nuns whom she saw in the convent and in the church where she worshipped (Pls 65, 67). The nuns of her paintings, on the other hand, are shown wearing the original veil which had not been in use since the beginning of the nineteenth century. It seems unlikely that the nuns would have been persuaded to pose wearing a head-covering which differed from the one they wore daily; and it is therefore possible that Gwen John painted the veil from imagination and with the image of Mère Poussepin in mind. Since it is known, however, that in painting Mère Poussepin she employed a model (or models) carefully dressed to resemble the subject (see note to Pl. 41), the possibility also exists that the two women portrayed in the paintings of nuns may in fact be models dressed in the costume of the Poussepin portrait.

This picture (Pl. 42) belonged for many years to Augustus and Dorelia John. In Augustus's old age it hung on the wall of his studio at Fryern Court. The Johns may have acquired it from Gwen John's 1926 London exhibition (*The little nun*, no. 19). Writing to Michel Salaman (3 June 1926), Gwen John said of it: 'I am glad you like "the little nun". I like it too. It is full of faults and cannot be called a picture can it? I value it for something in the little face a little sulky and sad.' Dorelia maintained that Gwen John considered this to be her best painting of a nun.

The other two versions of this picture appeared in the Memorial Exhibition at the Matthiesen Gallery, London, 1946 (nos. 34, 35). No. 34 in that exhibition is almost

34. Jeanne Foster was John Quinn's mistress and companion from 1918 until his death in 1924. Through him she made the acquaintance of many of the Paris artists, and her friendship with Gwen John lasted from 1920 until about 1925. The story of Gwen John's paintings of Mère Poussepin was contained in a letter to Quinn which she wrote in Paris on 4 October 1920. A portrait of Jeanne Foster which Gwen John began in late summer 1921 was never completed.

identical to this picture. Of it Oskar Kokoschka wrote (to Augustus John, 29 September 1946) 'I came, quite unexpected, to the Memorial Exhibition of your sister Gwyn [sic]. Among the paintings there is the portrait of a young nun (catalogue number 34) which seems to be the most touching work of art. The most innocent mastership of a Flemish painter of the mediaeval period together with the supreme taste and culture of a Chinese master of the Sung period seems to have entered into this single creation ... Tears came into my eyes before this masterpiece.'

43. The nun

See Pl. 42, note. There exist five finished versions of this picture and three others which are incomplete. All depict the same model with dark, arched eyebrows, her hands resting on a book before her. Sometimes her veil is moulded close to her head (like the veil in the portrait of Mère Poussepin), sometimes it is pulled down at an angle to her shoulder (as in this picture). Other variations occur in the relative position of the hands, and in the absence of the picture on the wall and of the flowers on the table.

The name Sœur Marie Céline (or sometimes Sœur Maria Celina) has been associated with one of these pictures since 1946 when it was sold under that title to its present owner.[35] The archives of the Sisters of the Presentation at Tours show that a sister of that name was *maîtresse de classe* at Meudon between 1921 and 1946. Her age (in 1921 she would have been fifty-two) seems to rule out the possibility that she was the model for this set of portraits.

44. Woman leaning on her hand

This drawing may be one of the many which Gwen John made when travelling by train, or else in the course of her journeys by public transport about the city of Paris and its environs. The suburb of Meudon where she went to live early in 1911 is a twelve-minute train ride from the Gare Montparnasse and many of her drawings of people in trains seem to have been done in the years between 1911 and 1918 when she was travelling, often daily, between her Meudon flat and the room at 6 rue de l'Ouest which she retained as a studio.

The sitter is unknown. The drawing has been exhibited under the title *The artist leaning on her hand*, but its idiom suggests that it is an observed subject rather than an imagined self-portrait.

45. Peasant woman with her bundle

The subject of this drawing was probably observed on a train or on one of the river boats by which Gwen John often travelled across Paris. Though she seems to have felt no inhibitions about drawing in public there were times when she put her observation of fellow-passengers to use as memory-training, as one of her letters to Rodin recounts. She describes to him how, returning by boat from the Pont de Suresnes, she passed the time studying the people on board, memorising them as subjects for later drawings. On that occasion, she adds, the resulting drawings could not be considered a success.

46. The little model

Another version of this picture shows the same girl, with a bow in her hair, standing beside a table (ill. 1982, Stanford University Museum of Art, no. 3). It was despatched to John Quinn on 12 February 1916. The version reproduced in this book also belonged to Quinn and was acquired by him not earlier than 1923. It may have been the picture entitled *Portrait d'enfant* which Gwen John exhibited (along with two others) at the 1923 Salon d'Automne (no. 940). All three were purchased from that exhibition by Quinn. Of them, Gwen John wrote to him: 'I am so glad and relieved that you like my Salon paintings. I was afraid you wouldn't because they are rather like those you have.'

47. The teapot (Interior: second version)

This picture is one of a set of four.[36] In subject matter, style and dimensions these pictures are more nearly alike

35. *Sœur Marie Céline* (sometimes called Sœur Maria Celina) (18 × 15 in.). Private collection, Australia.

36. The other three paintings of this set are: *Interior: the brown teapot*, 13 × 9½ in., Cleveland Museum of Art; *Study for the brown teapot*, unfinished, 12¾ × 9¾ in., National Museum of Wales, Cardiff; *The brown teapot*, 13 × 9 in., private collection USA (ill. exhibition catalogue, Davis and Long Company 1975, no. 23).

than those in any other set of paintings by Gwen John. The version now at Cleveland was despatched by Gwen John to John Quinn on 12 February 1916 though from their correspondence it seems possible that it was already finished in July of the previous year. 'I have several things ready to send' she wrote 'but I was advised a few weeks ago by the packer to wait a little till the danger at sea is over' (26 July 1915). These pictures may have been painted at 6 rue de l'Ouest which had a very similar fireplace and mantelpiece (though the wallpaper seems different from other rue de l'Ouest pictures) (see Pls 38, 39). On 29 September 1914 Gwen John, discussing the rumoured wartime evacuation of Meudon where she was living, told Quinn: 'I should have come to stay in my room at Paris which I keep on. I come in nearly every day to work as I have begun things there.'

Except for the picture sent to John Quinn (*Interior*) none of the paintings from this set was sold in Gwen John's lifetime. One of them was exhibited in her London exhibition in 1926 (no. 26).

48. Young woman holding a black cat

The woman who appears in this picture and in Pl. 49 was painted by Gwen John more often than any other model. In fact between forty and fifty paintings – more than a quarter of Gwen John's entire painting œuvre – portray her, or a girl whose image seems to derive from hers. The large number of portraits for which she is the sitter belong to the period 1920–8. She has not been identified but Gwen John's nephew Edwin was told by neighbours at Meudon that she was a local girl[37] and she is frequently shown posing in a room of the little attic flat at 29 rue Terre Neuve, Meudon where Gwen John lived from 1911. This room can be recognised by the angular shape of the window embrasure (usually placed near the top right of the canvas) which is often a feature of the paintings of this date. Nothing is known about the large black cat though it is included in several paintings of this model (see note to Pl. 36).

There are several variants of this picture. In some of them the cat is lying across the woman's lap; in some the cat is missing; and some of them show the woman wearing a spotted apron bound with a contrasting material whose angular shapes are made much of in the design of the paintings.

50. The convalescent

There are ten versions of this subject. The image was one Gwen John continued to explore over a number of years and more is known about the sequence of its creation than is usual with Gwen John's 'sets' of pictures. One version had certainly been largely completed in 1919. An undated letter written by Gwen John in the autumn of that year refers to it as a work in progress and one which she was about to complete for her friend Isabel Bowser. 'I will finish the little painting', Gwen John wrote. 'It is called the Convalescent. I was going to say to Isabel "it doesn't matter about the title does it Isabel? No doubt she was cured by Christian Science." That was a sort of joke.'[38] Other completed versions can be traced to the early twenties: one was owned by John Quinn and was acquired by him in either 1922 or 1923; one was purchased by Charles Rutherston from the Salon des Tuileries exhibition 1924 where it was shown as *La lettre* (no. 787);[39] one was brought over from Meudon in 1925 by Ethel Nettleship (Ida John's sister) and sold to Dorothy Samuel (*née* Salaman) as *Girl reading*, and Gwen John told Mrs Samuel in a letter dated 31 December 1925: 'The "girl reading" was painted about the Spring two years ago.' The version known as *The precious book* (Pl. 51) was done in 1926. The version shown in Pl. 50 was purchased in 1936 by Chloë and Grilda Boughton-Leigh. It is mentioned in their correspondence with Gwen John under the title *The letter*.

The pictures were painted in one of the rooms of Gwen

37. Gwen John herself described the girl as 'just a neighbour' to Mary Anderson Conroy (John Quinn's niece). (Gwen John exhibition catalogue, Stanford University Museum of Art 1982: 'Gwen John's Paintings' by Cecily Langdale, p. 19.)

38. This letter probably refers to the version now in the Tate Gallery. Isabel Bowser ('Miss Beaux-Arts' to Gwen John and other painter-friends in Paris) was one of the artists who employed Gwen John as a model. She died in October 1919. The Tate Gallery received its *Convalescent* by bequest in 1937 from her sister Rhoda, wife of the poet Arthur Symons.

39. Now in Manchester City Art Gallery.

John's little flat on the top floor of the building at 29 rue Terre Neuve, Meudon. In all of them the girl is shown in the same pose except for the position of the hands which in some versions are held slightly higher than in others. In all but two versions, the teapot and the pink cup appear. They are replaced by a book and a plate in the versions where the girl is holding a book instead of a letter; and in the 'book' version the girl wears a little shawl round her shoulders.

A pencil sketch of this subject was given by Gwen John to her friend Véra Oumançoff. It bore the title *La convalescente*, in Gwen John's hand. The date which it also bore – 4 June 1929 – referred to the day when the gift was made and not to the date of execution.

The pictures of *The convalescent* series can be identified as follows: (1, 2) the versions shown in this book (Pls 50, 51); (3) *The convalescent* ($13\frac{1}{4} \times 10$ in.), the Tate Gallery; (4) *The letter* ($16\frac{1}{2} \times 13$ in.), Manchester City Art Gallery; (5) *The convalescent* (16×13 in.), the picture bought by John Quinn (Gwen John Exhibition, Stanford, 1982, no. 8, ill., lent anonymously); (6) *The convalescent* ($15\frac{3}{4} \times 12\frac{3}{4}$ in.), formerly coll. Mrs Pitman (Gwen John Retrospective Exhibition, Arts Council, London, 1968, no. 43, ill.); (7) *The convalescent* ($15\frac{1}{2} \times 13\frac{5}{8}$ in.), private collection, GB; (8) *Woman seated* ($13\frac{1}{2} \times 10\frac{1}{2}$ in.), private collection, GB; (9) *Girl reading* (17×13 in.), formerly coll. Mrs Samuel, private collection, GB; (10) *Seated woman* ($10\frac{1}{2} \times 8\frac{1}{2}$ in.), private collection, USA.

The National Gallery of South Australia owns a picture by Gwen John called *The convalescent* which does not belong to this series.

51. The precious book

This picture was exhibited at Gwen John's exhibition at the New Chenil Galleries in London, 1926 (no. 40). It was bought by a Cheshire solicitor who, according to his descendant, the picture's present owner, 'had no particular interest in art and no known reason for being in London'. Perhaps he had seen an important notice of the exhibition by Mary Chamot which appeared in *Country Life* (5 and 19 June 1926) with a large reproduction of *The precious book* as its main illustration. Earlier the same year Gwen John had written to Ursula Tyrwhitt (7 April 1926) 'I've been doing a little picture for you

"the precious book".' Gwen John mentions that the picture is 'tiny' and there is every reason to suppose that it was in fact this canvas, which is the only painting known to have been given this name. Another painting (now in a private collection, USA), almost identical to this one in subject and dimensions, turned up, entitled *Seated woman*, at the Parke Bernet Galleries, New York in 1940.

See also note to Pl. 50.

52. Girl with a blue bow

The *Girl in grey* series to which this picture belongs is one of the most mysterious of the subject-groups painted by Gwen John. References to these paintings are difficult to trace in the documentation relating to Gwen John's lifetime; and her habit of using titles like *Portrait* and *Jeune fille*, when exhibiting her pictures, adds to the difficulty. Like the *Mère Poussepin* and *The convalescent* series, the *Girl in grey* pictures were probably produced over a period of some years but definite dates are impossible to establish. None of this series seems to have been sold to John Quinn or included in Gwen John's 1926 exhibition in London. Even the sitter's appearance is of little help. She seems to be the *Girl with a cat* model – though sometimes, as in *Girl with a blue bow*, a slightly older and more sophisticated version of that girl. But in other paintings of the series the likeness is more like a memory, elusive and insubstantial, and as it were at one remove from the original. Possibly some of the pictures were themselves models for other versions.

Refinement of tone and colour is carried, in this series, to the furthest limit. In some of the pictures the palette is restricted to black and white with possibly the addition of only two colours – vermilion and Naples yellow – and the effect of density and richness is created by a most subtle exploitation of induced colour. The tones are at times so close that the figure can seem to be absorbed into the background, which, though usually devoid of detail, conveys an image of dense and vaporous light. Attention is concentrated on the head and torso, and the hands are often concealed or excluded, as if to enhance the simplicity and grandeur of the image. The girl's simple blue- or green-grey dress is occasionally worn with a white collar. Sometimes she has a coral necklace; sometimes a blue bow is added at the neck.

Like most of the pictures in this series, *Girl with a blue*

bow remained unsold at Gwen John's death. It was exhibited at the Memorial Exhibition, London 1946 (no. 47, ill.)[40] together with three others from the same series (46, 48, 52 in the catalogue of that exhibition).

53. Girl in a hat with tassels

One other finished version of this picture is known: *Young woman wearing a large hat* ($18\frac{7}{8} \times 14\frac{3}{4}$ in.), private collection, USA. An unfinished portrait of the same girl wearing a different large hat is on the reverse of the *Study of a young girl* in the Hugh Lane Municipal Gallery of Modern Art, Dublin.

Exhibited at Gwen John's 1926 London exhibition (no. 23), this picture was purchased there by Dorothy Samuel and her husband who already owned two of Gwen John's pictures (see notes to Pls 3 and 50).

54. Young woman in a red shawl

This painting and another of the same subject were shown at the 1946 Memorial Exhibition (nos. 37 and 36). Stylistically they appear to belong to the early- to mid-1920s. An unfinished head and shoulders of the same subject ($9\frac{7}{8} \times 7\frac{7}{8}$ in.) is in a private collection in Great Britain.

A picture with the title *A woman in a red shawl* was promised by Gwen John to John Quinn in 1913 but was never sent to him and may never have been completed. No early picture with this title has come to light.

55. The pilgrim

In the late summer or autumn of 1925 Ethel Nettleship, Ida John's sister, brought a number of Gwen John's paintings from Paris to England. One of these was sold to Dorothy Samuel (see note to Pl. 50); *The pilgrim* was bought by Dorothy Samuel's brother Michel Salaman who had been Gwen John's close friend at the Slade (see Pl. 3 and note). They had not met for over twenty years but he was conscious, as he told her, of finding in it 'so much of the Gwen I know' (14 January 1926). Later that year he lent the picture to her London exhibition at the New Chenil Galleries (no. 22) and wrote to her after visiting it: 'My thoughts went back to our youth with its aims and hopes – and you seemed to be the only one of

40. The illustration was wrongly numbered 46.

that eager band who had been utterly faithful to those aspirations' (May 1926). Gwen John painted four versions of this picture,[41] each of them on what was, for her, a large canvas. In none of them is the elongation so extreme as in the Salaman version which, in other respects also, is more stylised than they are. Gwen John seems here to be demonstrating a concern with picture-pattern and the manipulation of large abstract areas of tone and colour within the picture's figurative context – preoccupations which look forward to the theories by which she was to become so fascinated (the theories of Lhote for example) in the last years of her life.

56. Girl with arms folded

This little girl is the subject of some of Gwen John's finest drawings, many of them in brush and wash. She has not been identified. A number of photographs found among Gwen John's papers show the child, sometimes alone and sometimes with a dark-haired woman. It is possible that she is Rosamund Manson (later Jugand), the daughter of Gwen John's friend Ruth Manson who stayed for a time with Gwen John at Meudon and in Brittany.

57. Little girl by lamplight

Between the autumn of 1918 and the autumn of 1919 Gwen John spent almost the entire year in Brittany. For most of that time she rented the ground-floor rooms of an empty château near the little town of Pléneuf on the north coast. During this period she seems to have abandoned painting almost completely but she produced dozens of important drawings. 'I haven't been painting in Brittany,' she wrote to John Quinn (13 October 1918), 'and the painting I did before is not so much what I want to do as my drawings are.' The subjects of these drawings were a few local children who were persuaded to pose for her after school in return for a little pocket-money. The child who is the subject of this drawing remains unidenti-

41. (1) *Young woman in a grey cloak* ($25\frac{1}{2} \times 18$ in.), The National Gallery of Canada, Ottawa; (2) *Woman with cloak* ($25\frac{1}{4} \times 19\frac{1}{2}$ in.), The Albright-Knox Art Gallery, Buffalo; (3) *Young woman holding a rosary* ($28 \times 20\frac{1}{2}$ in.), formerly coll. Mrs Rosemary Peto (Gwen John Retrospective Exhibition, Arts Council, 1968 (39) ill.).

fied. She is usually shown wearing a hat and holding her hands before her in the characteristic gesture of this drawing. Because it was done by lamplight, the drawing can be assumed to have been made during the winter months 1918–19. Ten years later, Gwen John gave some of the Brittany drawings to her friend Véra Oumançoff and wrote on the mounts of some of them titles which included the words *à la lampe* (by lamplight) and *à la lampe a pétrole* (by the light of a paraffin lamp). The mount of one of these drawings, which shows the child portrayed here, was inscribed in Gwen John's hand: *Petite fille (à la lampe)*. In Gwen John's 'lamplight' drawings, all of which were done in charcoal, vertical strokes behind the sitter's head suggest the darkened room.

58. Girl in a sunhat (Odette Litalien)

Odette Litalien (later Cardin), who was twelve years old when this drawing was made, spent her life near the village of Pléneuf on the north coast of Brittany. She and, occasionally, her sister Simone (Basset) posed for Gwen John in 1918–19 and in later life remembered her with affection.[42] The sisters recalled their pleasure in going after school to pose for her at the nearby château of Vauxclair. They were impressed by her kindness and by a certain aura of sadness that seemed to surround her and they retained a vivid memory of her physical appearance – 'sa taille mince, sa tête de madone.' It was through friendship with Rosamund Manson (see note to Pl. 56) that the Litalien sisters came to know Gwen John. No drawings of Simone Litalien have been identified. Odette is the subject of more than a dozen of Gwen John's most moving and majestic drawn portraits.

This drawing was given by Gwen John to Ursula

42. In the summer of 1958 I was fortunate in managing to trace Madame Basset in Brittany. She and her sister were thereafter the source of much valuable information concerning the Brittany drawings whose dates and subjects had been unknown up to that time. It was through Madame Basset and Madame Cardin that the identities of other models of drawings done in Brittany – Louise Gautier, Marie Hamonet and Elisabeth de Willman Grabowska – were eventually discovered. The names of Gwen John's child sitters were subsequently published in 1964 (Gwen John Exhibition, Faerber and Maison Ltd, London, November–December 1964).

Tyrwhitt in 1921. In 1964 Mrs Tyrwhitt presented it to the Ashmolean Museum.

59. Girl on a clifftop (Marie Hamonet)

Marie Hamonet (Ferrec) was born in 1907 and posed for Gwen John at Pléneuf in Brittany when she was between eight and ten years old. Gwen John was at that time living in a house in the village, and the drawings were done out-of-doors – often on the clifftops near the village where Gwen John would walk with the child on fine afternoons when she came out of school. She was usually dressed in her black school overall and wore her hair in pigtails. In Madame Ferrec's recollection[43] Gwen John always used charcoal. She made numerous drawings of the same pose, one after another – 'vite, vite, vite.' The addition of a monochrome wash on this and other Marie Hamonet drawings was probably done in the studio. The drawing was presented to Véra Oumançoff. It was mounted on grey Ingres paper and the mount was inscribed in Gwen John's hand: 'Portrait. June 12 28' (the date of presentation). It was exhibited in the 1968 Retrospective Exhibition (no. 69).

60. Interior (rue Terre Neuve)

The first mention of Gwen John's flat in the rue Terre Neuve, Meudon where she lived from 1911 to 1936 comes in a letter to Ursula Tyrwhitt (21 November 1910): 'Now I am going to tell you my little joy – I have taken a flat in Meudon! It only costs 45 francs every three months . . . It is the top storey of an old house quite near the forest . . . There are three rooms and a little kitchen and heaps of cupboards and a grenier and one gets into the gare Montparnasse in $\frac{1}{2}$ an hour.' One of the rooms faced east and she told Ursula: 'If you care to sleep there you shall have a lovely bedroom with the sun coming in early in the morning, and no street noises.' The room shown in this picture, with its characteristic window and wall shapes, appears also as the background to many of the portraits she painted at Meudon, and was perhaps the room facing east – the best light, after north, for a painting room; and in the pictures painted here light itself seems to become the subject, and atmosphere

43. Conversation with Mary Taubman, Paris, 22 November 1963.

129

an almost tangible reality. The room is the subject of five pictures. One of them (now in a private collection in Wales) is a version of this one and shows the table with the same arrangement of cups and teapot. In another, the teapot and cups are replaced by a straw hat and scarf.44 Two other paintings of the same view are known by the title *The Japanese doll* (see Pl. 61).

Interior was exhibited in 1924 at the Salon des Tuileries in Paris (no. 788) along with four other paintings. They were noticed by Charles Rutherston who already owned *The student* (see note to Pl. 14) and who contacted Gwen John with a view to buying one or more of them. Eventually he purchased *La lettre* (a version of *The convalescent*) and he then received *Interior* from Gwen John as a gift. The following year he presented all three pictures to Manchester.

Gwen John retained the flat at 29 rue Terre Neuve until the end of her life and most of the work that was discovered after her death was found here – much of it in this room, and in the grenier above. In 1936 she moved her living-quarters to the nearby rue Babie where, at no. 8, she had had constructed a little chalet on a piece of land she had owned and cultivated since 1926. In the late 1960s the building at 29 rue Terre Neuve was demolished to make room for housing development.

61. The Japanese doll

Gwen John never parted with this picture. Another very similar painting, apparently only recently completed, was sold by her to John Quinn's sister, Julia Anderson, probably in 1929. 'I am sorry the painting of the doll was not finished,' Mrs Anderson had written to her after

44. This picture was acquired in 1940 by the late Mr Arnold Palmer whose account of its purchase throws some light on the reason for the delay in presenting Gwen John's work to the public immediately after her death: 'In the summer of 1940 I heard that there was to be an exhibition of her work at Matthiesen. I went to the gallery and found all the works standing upright on the floor, waiting to be hung. I asked if works were being sold before the show; was told yes; and bought (my picture). Before the pictures could be hung, the blitz began, the show was indefinitely postponed, and the canvases removed to a safer place' (Arnold Palmer to Mary Taubman, 16 March 1968).

a visit to Meudon the previous year. No other paintings or drawings of the Japanese doll are known (though two other dolls were the subject of some wash drawings). Many years earlier Gwen John had written to Rodin a touching account of the pleasure and solace she found in the contemplation of Japanese artefacts, and described how, racked by pain after a day of difficult posing, she found distraction by walking to 'a certain shop on the Boulevard Montparnasse near the Observatoire where they have Japanese prints in the windows and dolls and all kinds of other Japanese things. When I go for a walk I always go there to look in the windows. But tonight the wind was so piercing I couldn't stay long to look at them ...' (undated letter *c.* 1908).

62. Profile study of Arthur Symons

A prolific output of poems and critical writing throughout the 1890s, and the publication in 1899 of his book *The Symbolist Movement in Literature* had established Arthur Symons's substantial reputation in the London literary world when, in 1902, he first met and become friendly with Augustus John. Later, following a devastating mental breakdown in the summer of 1908, he came to attribute his recovery to the friendship and support Augustus offered. John Quinn was another who offered him help at that time. But it was through neither Augustus John nor John Quinn that Symons's friendship with Gwen John was established. She came to his notice following the death in 1919 of her friend (and his sister-in-law) Isabel Bowser for whom she had made a number of drawings. Symons saw and was impressed by these drawings and subsequently purchased, direct from Gwen John, a number of drawings for himself. He immediately wrote to John Quinn to bring to his attention this unknown artist. Quinn, who had been Gwen John's chief patron for almost ten years, reported the matter to her with some glee: 'I congratulated him upon his discovery but [told him] that he had not discovered your work to me' (14 February 1920).

In 1921 Gwen John was persuaded by Arthur Symons and his wife to make one of her rare visits to England and stayed with them at their home, Island Cottage, Wittersham, in Kent. This was also for her a rare opportunity to make, in the relaxed domestic atmosphere which suited her, a prolonged portrait-study of a man.

This study took the form of a number of charcoal head and shoulders drawings of Arthur Symons and it is unique in her œuvre – the only substantial series of drawings from an adult male model she is known to have made.

63. A nun on her deathbed

This drawing, sometimes known as *Sleeping nun*, seems more likely in fact to show a nun on her deathbed. Gwen John is known to have made deathbed drawings at the request of the nuns on at least one other occasion. The subject was a priest – a personal friend of hers – who died in the autumn of 1920. The circumstances are reported in a letter from Jeanne Foster to John Quinn (4 October 1920). A deathbed drawing by Gwen John which shows a man dressed in what appears to be a priest's robe was owned in the 1930s by the Cornish artist George Lambourn, a friend of the John family.

There are eight versions of *A nun on her deathbed*. One of them, a charcoal drawing now in the National Museum of Wales, appears to have been done as an objective recording of fact. The others are all concerned with the exploration of the formal pictorial potential of this original image.

The factual depiction of death has an important place in the history of nineteenth century realism. One of its most famous instances occurs in Émile Zola's novel *L'Œuvre* when the artist Claude Lantier paints a picture of his dead child. The scene was inspired by the painting known as *L'enfant mort* by Albert Dubois-Pillet. It was a picture Gwen John would almost certainly have seen when she spent some weeks at Le Puy en Velay with Ambrose McEvoy and Augustus John in the summer of 1900. Ten years earlier the picture had been acquired by the local museum following the death of Dubois-Pillet at Le Puy.

64. Woman in a mulberry dress

Six finished and three unfinished canvases can be considered as belonging to this set of portraits.[45] In all nine

there is a sense of the immediacy of the artist's response to her sitter; all nine are characterised by brushwork which, in comparison with most of Gwen John's painting, is dashing and spontaneous. In this more than in any of the other long series, the creative process is visible on the canvas, with second thoughts and adjustments and the exploitation of accidentals all contributing to the beauty of the final image. The hands are sometimes small and claw-like, sometimes exaggeratedly large and flat, like flippers – their form expressionistically summarised.

Six of the pictures show the girl seated beside a pink-spotted curtain; in one version she sits on a ladder-back chair beside a round table.

66. A stout lady, and others, in church

The hundreds of studies made by Gwen John in church cannot be dated with precision. The set to which this drawing belongs depicts figures in the church at Meudon where she worshipped from 1913 onwards. Another version of this same subject is contained in one of two albums of drawings auctioned at the 1927 sale of John Quinn's collection.[46] It can therefore be assumed to have been made prior to 1924, the year of Quinn's death. The drawing reproduced here is one of a group of three belonging to the National Museum of Wales. These drawings show a marked concern with the exploration

45. They are: (1), (2): The versions shown here (Pls 64 and 65); (3) *Woman with hands crossed* (sometimes called *An impression*) (16 × 13 in.), private collection, New York; (4) *Young woman in a mulberry dress* (20 × 15 in.), formerly collection Mary Anderson Conroy and Family; (5) *Young woman in a mulberry dress* (16 × 10½ in.), private collection, New York; (6) *La concierge* (17¾ × 14½ in.), private collection, G.B.; (7) *Study for girl in a mulberry dress* (13 × 9½ in.), private collection, G.B.; (8) *Study of a young woman in a mulberry dress* (14¼ × 9¼ in.), private collection, USA; (9) *Study for young woman in a mulberry dress* (13 × 9¼ in.), National Museum of Wales, Cardiff.

Nos 2, 3 and 4 on this list were in the Quinn collection; no. 3 was exhibited at the Salon d'Automne 1923 (no. 941 or 942); no. 6 was exhibited at the Salon des Tuileries in 1924 (no. 786); nos 2, 3, 4, 5, 8 are reproduced in the catalogue of the exhibition *Gwen John*, Davis and Long Company, New York, 1975 (nos 16, 12, 14, 13, 15).

46. These albums, whose contents are now dispersed, were reassembled by Betsy G. Fryberger for the Gwen John exhibition held at Stanford University Museum of Art, 1982 and published in her catalogue to that exhibition (nos 26–41 ill.).

of formal pictorial possibilities. In one of the Cardiff versions, as in the Quinn version also, the reduction to areas of tone and colour of much of the picture's figurative content has not yet been arrived at; and what have here become near-abstract shapes in the middle-distance, are shown there as recognisable portraits of individuals drawn with a rapid and economical line.

67. A nun in church
A version of this drawing, like the previous one (Pl. 66), appeared in one of the albums sold at the final auction of the John Quinn collection; and two more are in the collection of the National Museum of Wales.

Gwen John exploited the large simple shapes of the nun's habit and coif to produce some of her broadest essays in pattern-making with tone and colour. But even in the boldest of these the mysterious presence of the figure itself seems only to be enhanced.

68. Souvenir du dimanche des Rameaux
The picture's title, translateable as *Remembrance of Palm Sunday*, was how Gwen John herself described this image. Another, very similar, drawing from the same set was among those given by her to her friend Véra Oumançoff. On the back of the mount it bore this title in Gwen John's hand and the date of presentation 'Avril 1932'.

Four other pictures from the set are owned by the National Museum of Wales. In general design they are, like the Oumançoff version, almost identical with this one; each differs subtly from the others in tone and in colour.

69. Girl carrying a palm frond
This picture, like Pl. 68, appears to be derived from a figure observed on Palm Sunday. Two other versions of the subject and two studies for the head alone are also in the collection of the National Museum of Wales.

70. Still life with a vase of flowers
Another version of this picture is in the City of Manchester Art Galleries. It has the title *Flowers* and was purchased by Charles Rutherston in May 1926, probably from Gwen John's exhibition at the New Chenil Galleries (May–July 1926) no. 20. The Manchester pic-ture is much the more direct and spontaneous of the two and is almost certainly the earlier version. *Still life with a vase of flowers* is a more classical and conceptual image and has the appearance of being a considered and reflective development of the original.

71. Red house at twilight
After taking up residence at Meudon Gwen John made occasional landscape studies in watercolour and gouache. Many of them have as their subject the wooded lanes and village-like streets of Meudon itself. The location of this picture is not known. It is probably among the last she painted. The subject appears, in two tiny sketches measuring less than $1\frac{1}{2}$ square inches, on a page of compositional notes dated '11 Mars 32'.

72. Bridget Bishop
Bridget Bishop (now Mrs Latimer), the eldest daughter of Gwen John's friend Louise Salaman (Louise Bishop) was in Paris throughout the late autumn, winter and spring 1928–29. Shortly after her arrival there she and her mother spent an evening with Gwen John. In a letter to Mrs Bishop, Gwen John expressed her delight at the meeting and Mrs Bishop then replied with the proposal that her daughter should sit for a portrait. The ensuing correspondence throws some light on Gwen John's attitude both to her sitters and to the making of a portrait. A sense of conflicting eagerness and reluctance to undertake the commission is apparent in her letters to Mrs Bishop from this time on, and can already be discerned in the letter she wrote accepting it: 'Dear Louise, Thank you for proposing that I should do a portrait of your daughter. I should like to very much. I shall be away for the next two or three weeks – two, I think. I will let you know when I return. Yours with love Gwen' (11 October 1928). On 15 December she explained 'This is the reason I am putting off your daughter's portrait. I don't want her to come to my logement, which has a look of poverty and four flights of *very* dirty stairs to come up and I am waiting for the workmen to put the floor into a place I am going to use as a studio. They promised it would be done some months ago! There Biddie will have nothing depressing to feel or see, and a lovely garden to go in. I shall not want many sittings, about five, and not all on consecutive

days . . . I should like to know *for certain* how long she will be in Paris.' After further procrastination (the studio was still unfurnished) the portrait was begun in the room where Gwen John slept in the flat at 29 rue Terre Neuve. 'Bridget gave me the first sitting this afternoon' she wrote (2 March 1929). 'I don't think she was tired or bored because the sitting was very short, as I had an engagement (but I was able to decide on the pose). She is coming again on Tuesday.' Mrs Latimer remembers that first sitting and the careful consideration Gwen John gave to the choice of her costume – blue-grey jacket and skirt, a silk and wool jersey of the same colour, with a necklace of Wedgwood beads, and a dark blue hat. She held a book on her lap and was posed against a plain uncurtained wall. Even after the portrait was begun a sense of unease continued to pervade Gwen John's letters to Mrs Bishop. That she felt in sympathy with her sitter is beyond question. 'I am so happy with her', she wrote (22 March 1929). 'I think one of her beautiful qualities (that is a stupid word – qualities – but I cannot think of a better) is her calm.' But she seemed unable to rid herself of the idea that her subject was a guest rather than a model – a notion that was both distracting and inhibiting. There were many more sittings than the five that had been envisaged at the start, and at least one canvas was discarded. Eventually, in May 1929, Bridget Bishop returned to England. But the portrait was not abandoned and for many years Gwen John seems to have continued to think of it as a work in progress. On 20 February 1933 she wrote in reply to a letter from Mrs Bishop, 'It is kind of you not to feel annoyed that I haven't yet sent over the portrait . . . Problems of technique have made me leave everything, even the things I want very much to do . . . I don't want [Biddie] to pose again. If I can finish it as I would like it to be done I shall send it over before Easter.' The picture was never sent. It remained in Gwen John's possession until her death.

Exhibitions

This list includes the exhibitions cited in the introduction and notes; all exhibitions devoted to the work of Gwen John; and other exhibitions of particular relevance.

1900–11 London. New English Art Club (1900 spring and winter; 1901 spring and winter; 1902 spring and winter; 1908 spring; 1909 winter; 1910 spring; 1911 winter).

1903 London. Carfax and Co., *Paintings, pastels, drawings and etchings by Augustus E John. Paintings by Gwendolen M John.*

1911–12 Manchester. City Art Gallery (and other City Art Galleries in Great Britain), *Paintings and drawings purchased by the Contemporary Art Society* (with the addition of a number of pictures loaned to the exhibition).

1913 London. Goupil Gallery, *Paintings and drawings purchased by the Contemporary Art Society* (with the addition of a number of pictures loaned to the exhibition).

1913 New York. Armory of the 69th Regiment, *International Exhibition of Modern Art.*

1919–23 Paris. Salon d'Automne (1919, 1920, 1921, 1923).

1920–25 Paris. Société Nationale des Beaux Arts (1920, 1924, 1925).

1920 Paris. Société des Artistes Français.

1924 Paris. Salon des Tuileries.

1925 London. New English Art Club, *Special Retrospective Exhibition.*

1926 London. New Chenil Galleries, *Paintings and drawings by Gwen John.*

1927 New York. American Art Association Inc., *The John Quinn Collection: Paintings and Sculpture of the Moderns.*

1946 London. Matthiesen Ltd., *Gwen John Memorial Exhibition* (Foreword by Augustus John).

1946 London. Arts Council of Great Britain, *Gwen John* (touring exhibition).

1952 London. The Tate Gallery and The Arts Council, *Ethel Walker, Frances Hodgkins, Gwen John* (essay on Gwen John by John Rothenstein).

1952 Edinburgh. The College of Art, *Gwen John. An exhibition of sixty drawings* (Introduction by Allan Carr).

1958 London. The Matthiesen Gallery, *Gwen John.*

1961 London. The Matthiesen Gallery, *Gwen John* (Introduction by Myfanwy Piper).

1964 London. Faerber and Maison Ltd., *Gwen John* (Introduction by Mary Taubman).

1965 New York. Davis Galleries, *Gwen John.*

1968 London. Arts Council Gallery, *Gwen John, A Retrospective Exhibition* (Introduction by Mary Taubman). Shown also at Cardiff and Sheffield.

1970 London. Faerber and Maison Ltd., *Gwen John* (Introduction by S[tefanie] M[aison]).

1975 New York. Davis and Long Company, *Gwen John, A Retrospective Exhibition* (catalogue by Cecily Langdale).

1976 London. Anthony d'Offay Gallery, *Gwen John* (Introduction by Mary Taubman).

1976 Cardiff. National Museum of Wales, *Gwen John at the National Museum of Wales* (catalogue by A. D. Fraser Jenkins).

1978 Washington, D.C., Hirshhorn Museum and Sculpture Garden, '*The Noble Buyer': John Quinn, Patron of the avant-garde* (catalogue by Judith Zilczer).

1979–80 London. Royal Academy of Arts, *Post-Impressionism* (catalogue edited by John House and Mary Anne Stevens).

1982 Stanford, California. Stanford University Museum of Art, *Gwen John – paintings and drawings from the collection of John Quinn and others* (catalogue by Betsy G. Fryberger with an essay by Cecily Langdale).

1982 London. Anthony d'Offay Gallery, *Gwen John* (Introduction by Michael Holroyd).

1985 London. The Barbican Art Gallery, *Gwen John: an interior life* (catalogue by Cecily Langdale with an introduction by A. D. Fraser Jenkins).

Index of Plates

Numbers refer to plates, not pages